LETTERHEAD & LOGO DESIGN

8

First published in the United States of America by
Rockport Publishers, Inc.
33 Commercial Street
Gloucester, Massachusetts 01930-5089
Telephone: (978) 282-9590
Fax: (978) 283-2742
www.rockpub.com

ISBN 1-56496-975-4

10 9 8 7 6 5 4 3 2 1

Design and Typography: Top Design Studio, Los Angeles, www.topdesign.com

Printed in China

LETTERHEAD & LOGO DESIGN 8

TOP DESIGN STUDIO, LOS ANGELES

GLOUCESTER MASSACHUSETTS

ROCKPORT PUBLISHERS

CONTENTS

"style
is a simple way of saying
complicated things."

—JEAN COCTEAU

INTRODUCTION

A graphic designer's job is to successfully represent the client's message visually. At Top Design, we believe that effective design is grounded in simplicity; that economy of design prevents visual overload, revealing the distinct personality of the client and the message they wish to impart. Much of the work selected for this book relies on the power of subtlety to convey the style and sensibility of both client and designer.

The selection process was a collaborative effort—inspiring, exciting, and at times, daunting—as we culled approximately 500 pieces from more than 1,500 impressive entries submitted by designers worldwide. The work appearing in this book met our benchmarks of outstanding design through the use of spare, elegant typography and striking bold and neutral color palettes, as well as the expert handling of design elements throughout the letterhead systems. Each logo chosen to appear successfully communicates the intention and personality of the client it represents, through the use of icons, symbols, hand-rendered illustration, and typography.

We hope this book provides enjoyment to the casual reader and inspires fresh, creative solutions for designers worldwide.

top

Top Design Studio is a Los Angeles–based graphic design firm, established in 1991 by Peleg Top, principal and creative director. Following Peleg's passion for well-crafted logos and brand identities, Top Design Studio quickly gained status in the design community. Prestigious clients in the music and entertainment industries as well as not-for-profit organizations contributed to the studio's success and growing reputation. Peleg serves as chair of the Grammy Awards album packaging committee and is past president of the Graphic Artists Guild, southern California chapter. Top Design Studio has been featured in such major design publications as *Print*, *HOW*, and *Communication Arts*, and has received numerous awards for design excellence.

TOP DESIGN STUDIO » 11108 RIVERSIDE DRIVE, LOS ANGELES, CA, 91602 » WWW.TOPDESIGN.COM

top design studio
11108 riverside drive, west toluca lake, ca 91602 usa
phone 818 985 1100 >> fax 818 985 1101 >> **topdesign.com**

discover. visualize. create.™

11108 riverside drive, west toluca lake, ca 91602 usa
phone 818 985 1100 >> fax 818 985 1101 >> www.topdesign.com
peleg top >> principal >> ext. 201
peleg@topdesign.com

top design studio
11108 riverside drive, west toluca lake, ca 91602 usa

discover. visualize. create.™

peleg top
peleg@topdesign.com

1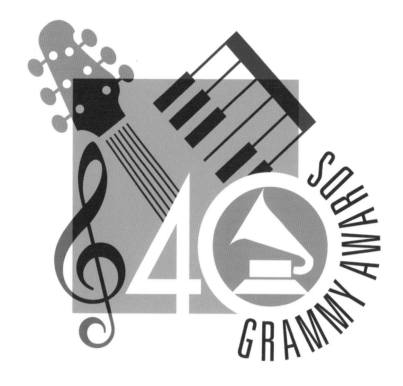

2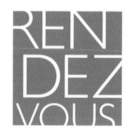

3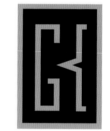

4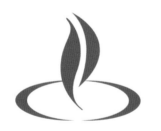

5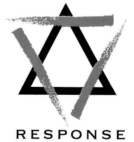

1 **THE RECORDING ACADEMY** | GRAMMY AWARDS TELECAST LOGO

2 **RENDEZVOUS ENTERTAINMENT** | RECORD COMPANY LOGO

3 **GK COMMUNICATIONS** | PR AGENCY LOGO

4 **UNITARIAN UNIVERSALIST CHURCH** | LOGO FOR VERDUGO HILLS, CALIFORNIA CHURCH

5 **RESPONSE** | LOGO FOR JEWISH GAY FAMILY SUPPORT GROUP

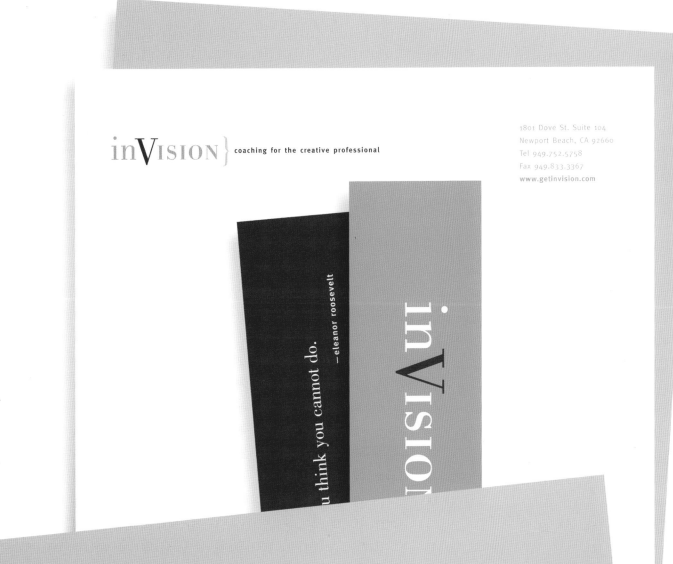

MARCELO COELHO PHOTOGRAPHY
8800 Venice Boulevard Suite 202 Los Angeles, California 90034
telephone 310.204.4244 facsimile 310.204.4216
email info@marcelocoelho.com web www.marcelocoelho.com

MARCELO COELHO PHOTOGRAPHY
8800 Venice Boulevard Suite 202 Los Angeles, California 90034
telephone 310.204.4244 facsimile 310.204.4216
email info@marcelocoelho.com web www.marcelocoelho.com

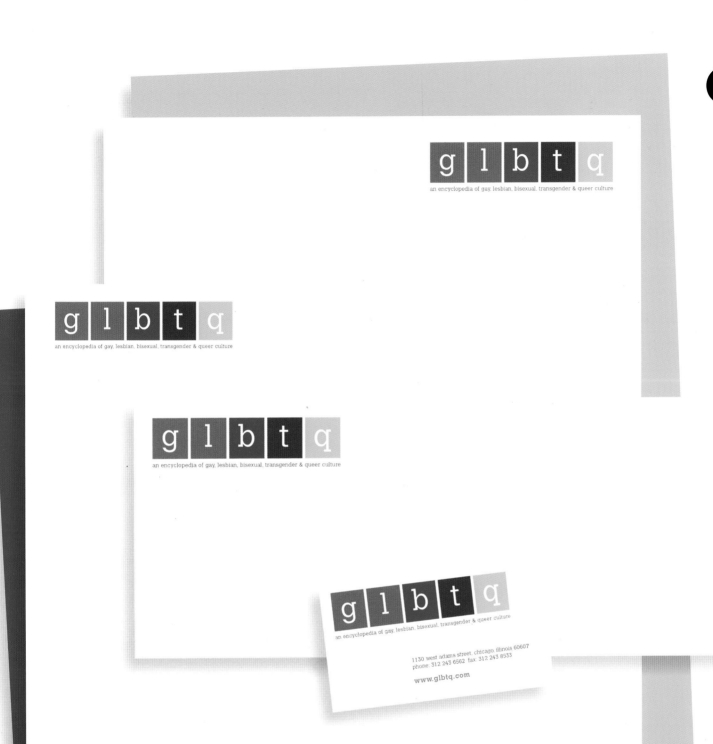

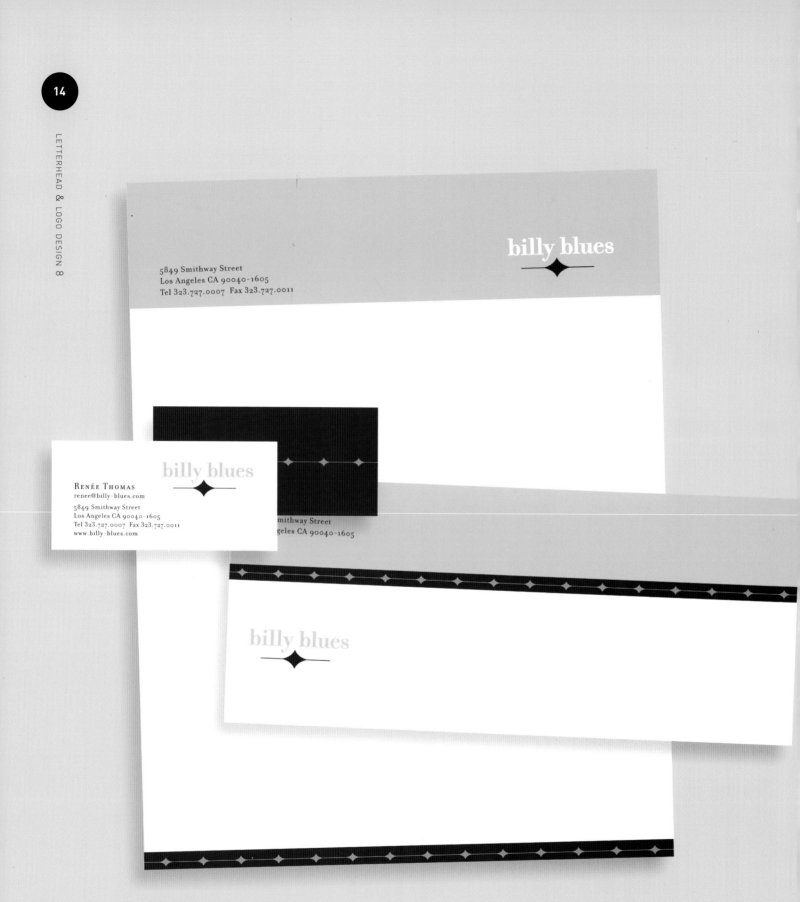

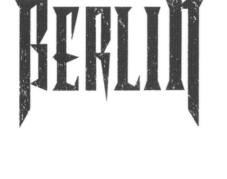

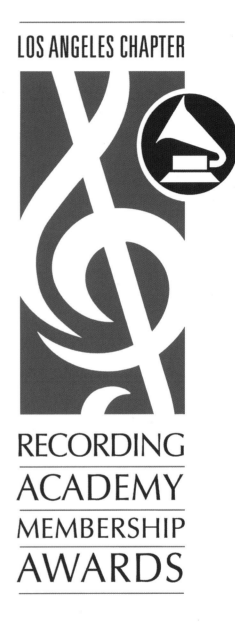

PROFESSIONAL SERVICES

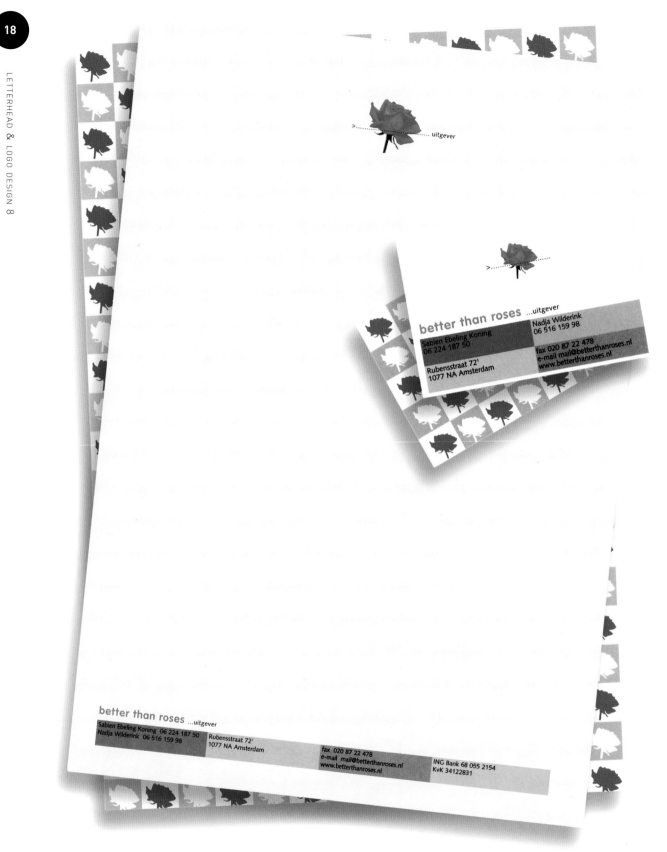

HYBRID

76 Federal Street
Boston Massachusetts
02110

Telephone
617 728 - 4442

Telefax
617 728 - 4448

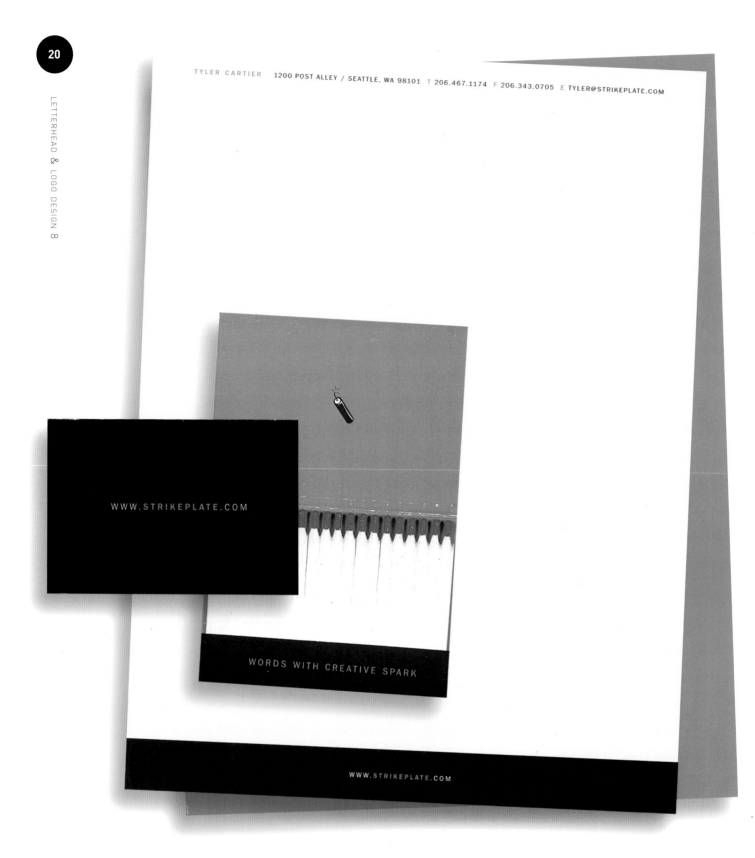

TYLER CARTIER 1200 POST ALLEY / SEATTLE, WA 98101 T 206.467.1174 F 206.343.0705 E TYLER@STRIKEPLATE.COM

WWW.STRIKEPLATE.COM

WORDS WITH CREATIVE SPARK

WWW.STRIKEPLATE.COM

PLATFORM CREATIVE | ART DIRECTOR **ROBERT DIETZ** | DESIGNER **RENEE YANCY** | CLIENT **STRIKEPLATE, TYLER CARTIER**

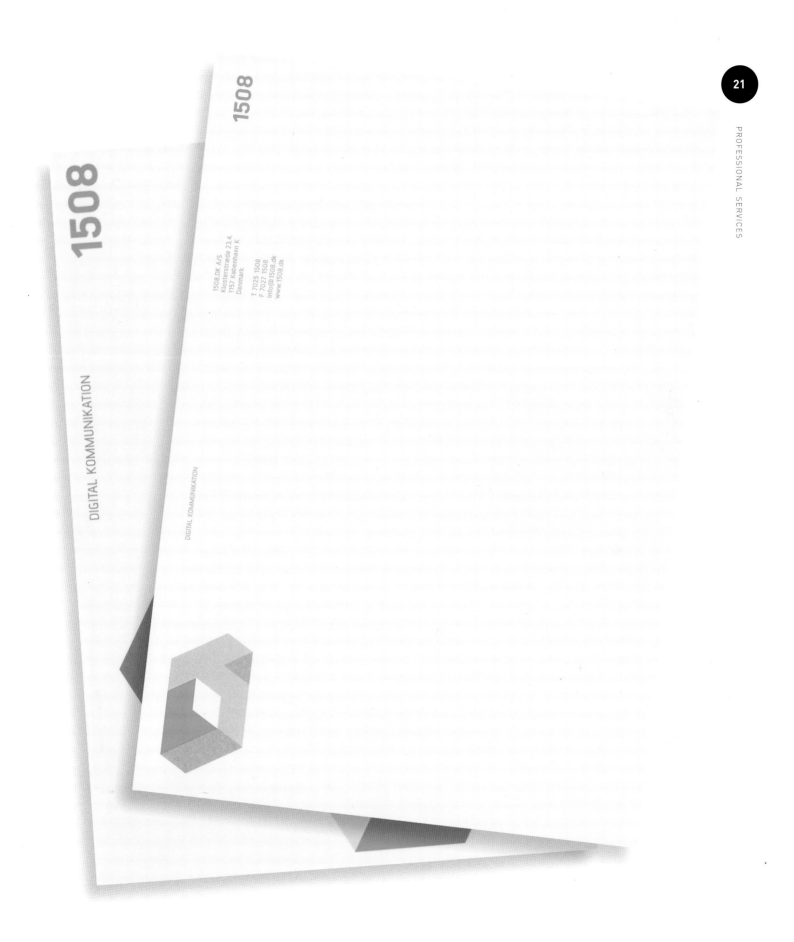

1

Expand Beyond™

2

3

4

H A T C H

1 **LISKA + ASSOCIATES** | ART DIRECTOR **STEVE LISKA** | DESIGNERS **RUDI BACKART, STEVE LISKA** | CLIENT **EXPAND BEYOND**

2 **I. PARIS DESIGN** | ART DIRECTOR **ISAAC PARIS** | CLIENT **CITY PLUMBING, INC.**

3 **SAYLES GRAPHIC DESIGN** | ART DIRECTOR **JOHN SAYLES** | CLIENT **CATCH SOME RAYZ**

4 **GOTTSCHALK + ASH INTERNATIONAL** | ART DIRECTOR **STUART ASH** | DESIGNER **SONIA CHOW** | CLIENT **HATCH DESIGN INC.**

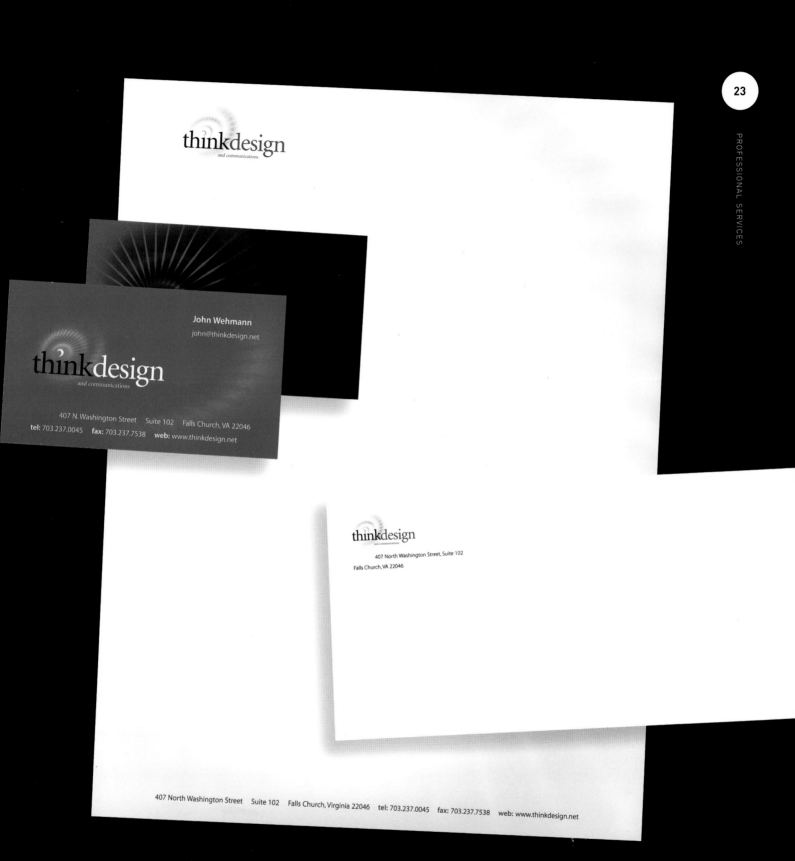

John Wehmann
john@thinkdesign.net

407 N. Washington Street Suite 102 Falls Church, VA 22046
tel: 703.237.0045 **fax:** 703.237.7538 **web:** www.thinkdesign.net

407 North Washington Street, Suite 102
Falls Church, VA 22046

407 North Washington Street Suite 102 Falls Church, Virginia 22046 **tel:** 703.237.0045 **fax:** 703.237.7538 **web:** www.thinkdesign.net

>

MONDERER DESIGN

2067 Massachusetts Avenue
Cambridge, MA 02140-1337

617 661 6125 FAX 661 6126
www.monderer.com

> **Design + Visual Communications**

>

MONDERER DESIGN | ART DIRECTOR **STEWART MONDERER** | DESIGNER **JASON MILLER** | CLIENT **MONDERER DESIGN**

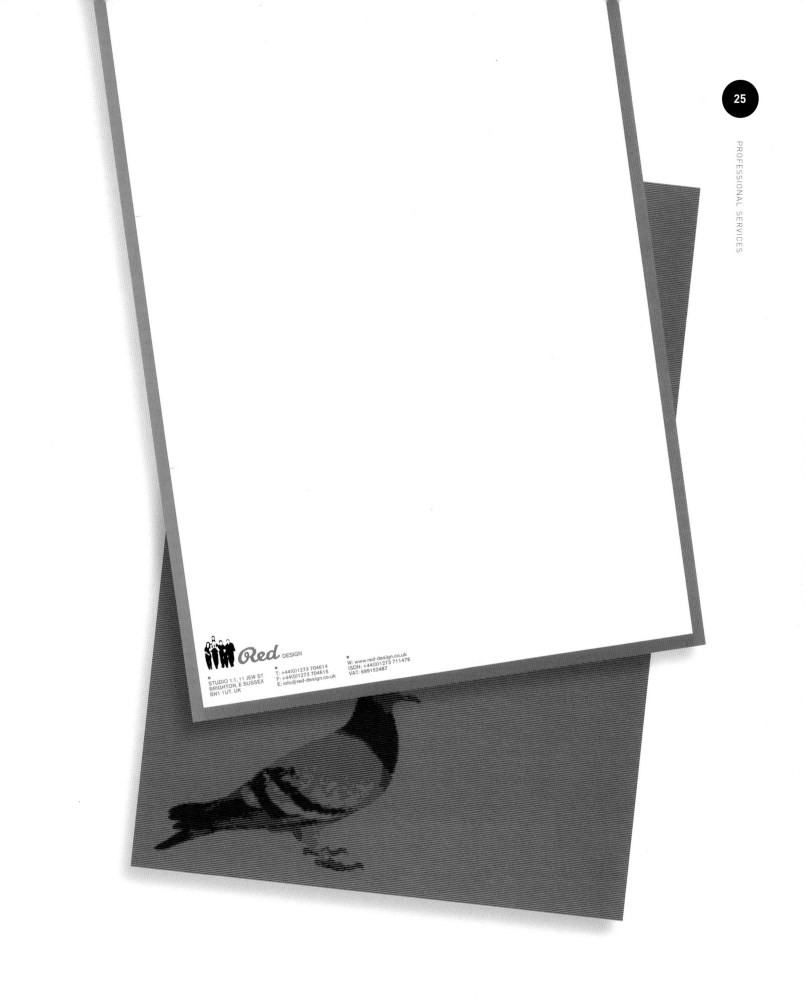

Red DESIGN

STUDIO 1.1, 11 JEW ST
BRIGHTON, E SUSSEX
BN1 1UT. UK

T: +44(0)1273 704614
F: +44(0)1273 704615
E: info@red-design.co.uk

W: www.red-design.co.uk
ISDN: +44(0)1273 711476
VAT: 699152487

RED DESIGN | ART DIRECTORS **ED TEMPLETON, HAMISH MAKGIU** | DESIGNER **RED DESIGN** | CLIENT **RED DESIGN**

DAVIDLAWRENCEPHOTOGRAPHY
136 GRAND STREET #4WF NEW YORK NY 10013 T 212 274 0710 F 212 274 0712 DALJR@AOL.COM

DAVIDLAWRENCEPHOTOGRAPHY
136 GRAND STREET #4WF NEW YORK NY 10013 T 212 274 0710 F 212 274 0712

136 GRAND STREET #4WF NEW YORK NY 10013
T 212 274 0710 F 212 274 0712 DALJR@AOL.COM
DAVIDLAWRENCE
PHOTOGRAPHY

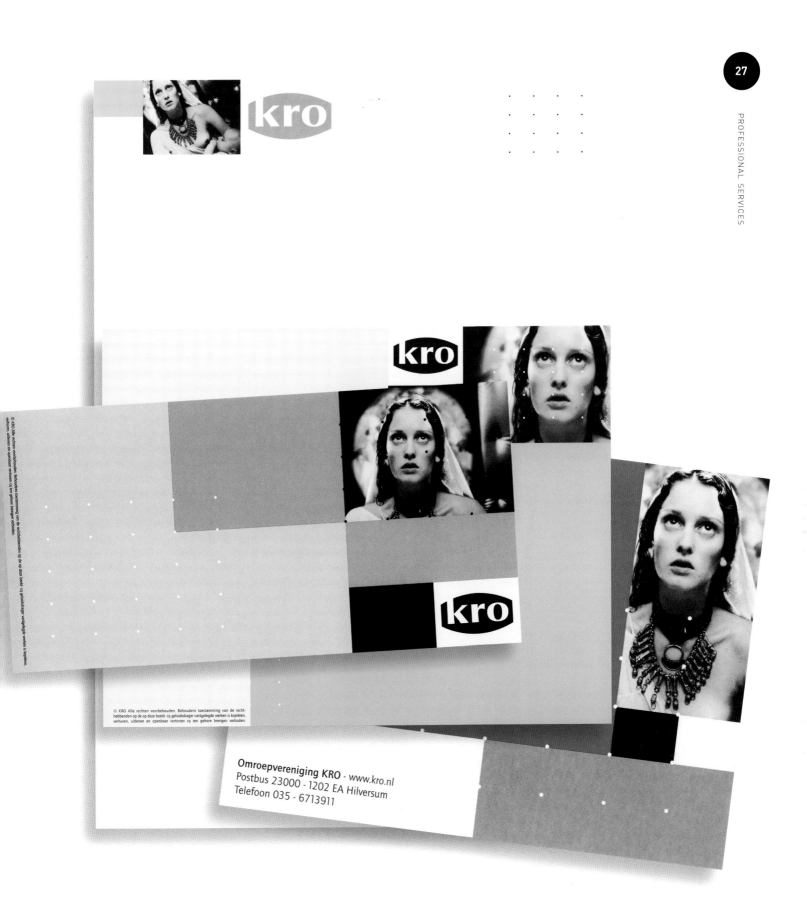

Omroepvereniging KRO - www.kro.nl
Postbus 23000 - 1202 EA Hilversum
Telefoon 035 - 6713911

LAVA GRAPHIC DESIGNERS | ART DIRECTORS **HANS WOLBERS, HUGO ZWOLSMAN** | CLIENT **KRO TELEVISION BROADCASTING CO.**

Our de Young

M.H. de Young Memorial Museum
Administrative Offices, 233 Post Street
San Francisco, California 94108

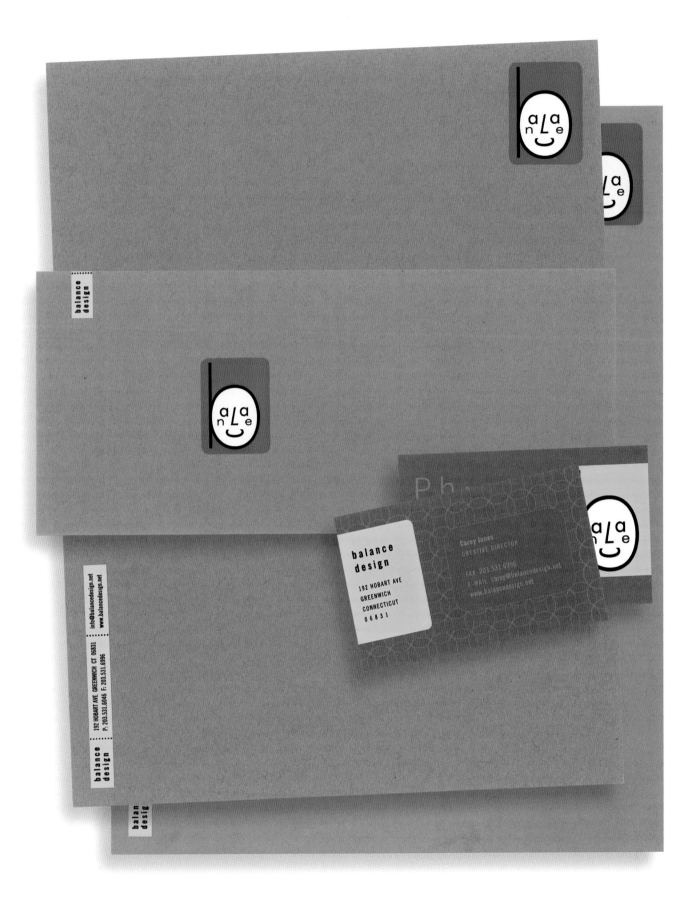

BALANCE DESIGN | ART DIRECTOR **CAREY JONES** | CLIENT **BALANCE DESIGN**

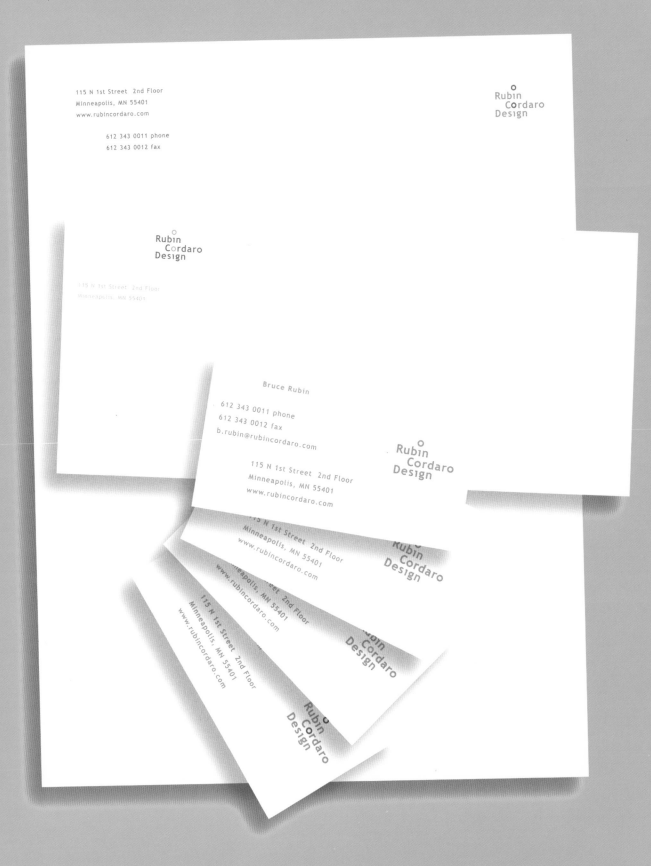

115 N 1st Street 2nd Floor
Minneapolis, MN 55401
www.rubincordaro.com

612 343 0011 phone
612 343 0012 fax

○
Rubin
Cordaro
Design

Bruce Rubin

612 343 0011 phone
612 343 0012 fax
b.rubin@rubincordaro.com

115 N 1st Street 2nd Floor
Minneapolis, MN 55401
www.rubincordaro.com

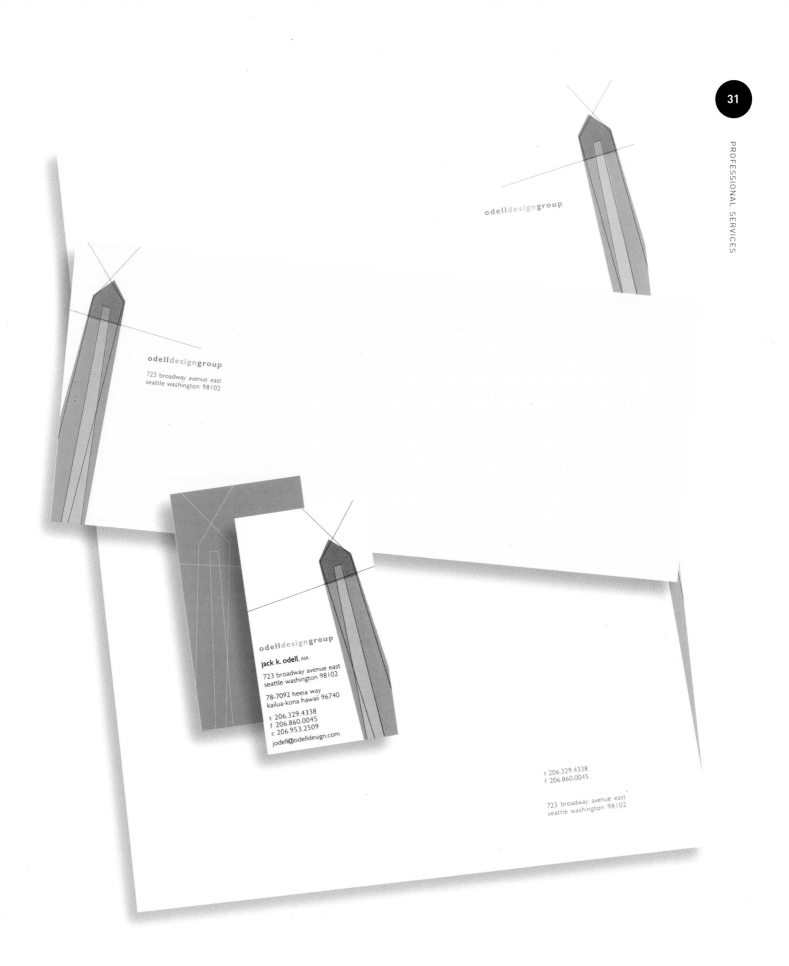

odelldesigngroup

odelldesigngroup
723 broadway avenue east
seattle washington 98102

odelldesigngroup

jack k. odell, AIA

723 broadway avenue east
seattle washington 98102

78-7092 heeia way
kailua-kona hawaii 96740

t 206.329.4338
f 206.860.0045
c 206.953.2509
jodell@odelldesign.com

t 206.329.4338
f 206.860.0045

723 broadway avenue east
seattle washington 98102

MONSTER DESIGN | ART DIRECTORS HANNAH WYGAL, THERESA VERANTH | DESIGNER HANNAH WYGAL | CLIENT ODELL DESIGN GROUP

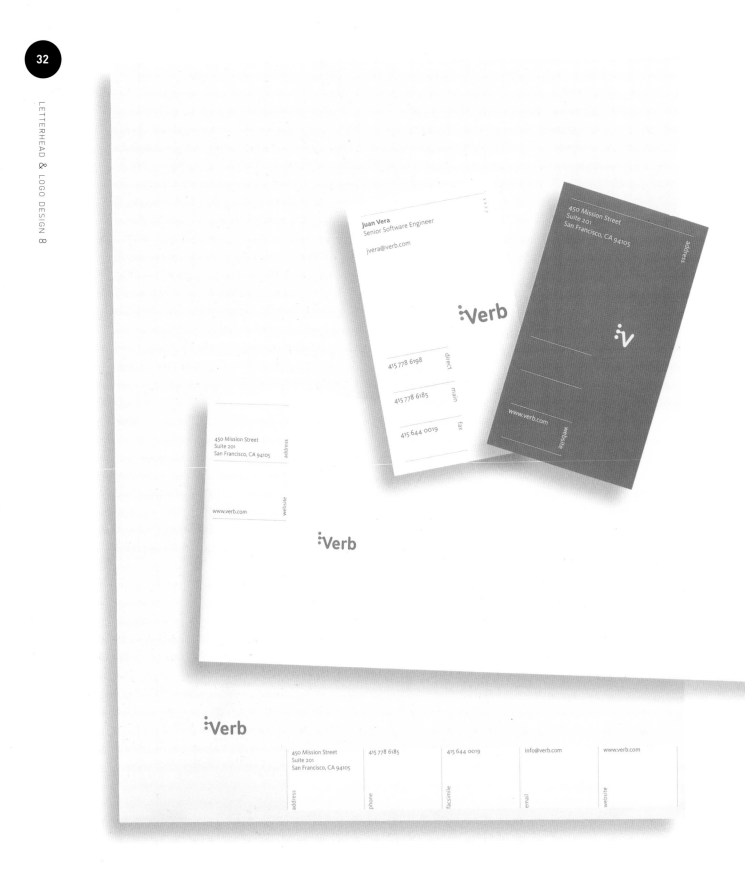

Verb

BURD & PATTERSON

GRAPHIC DESIGN STUDIO

BURD & PATTERSON

GRAPHIC DESIGN STUDIO

& 2223 Grand Avenue Unit 4
West Des Moines, Iowa 50265
cell 515 710 9400
home studio 515 256 9400
brian@burdandpatterson.com
www.burdandpatterson.com

BRIAN C. PATTERSON
Client Relations Director

BURD & PATTERSON

GRAPHIC DESIGN STUDIO

2223 Grand Avenue Unit 4 • West Des Moines, Iowa 50265 • 515-710-9400
info@burdandpatterson.com • www.burdandpatterson.com

BURD & PATTERSON | ART DIRECTORS TRENTON BURD, BRIAN PATTERSON | DESIGNER TRENTON BURD | CLIENT BURD & PATTERSON

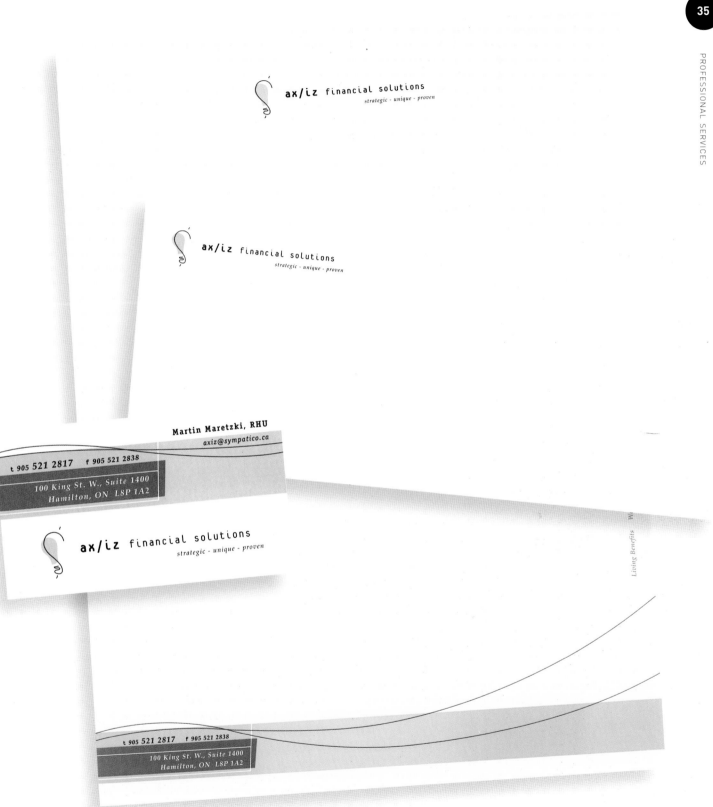

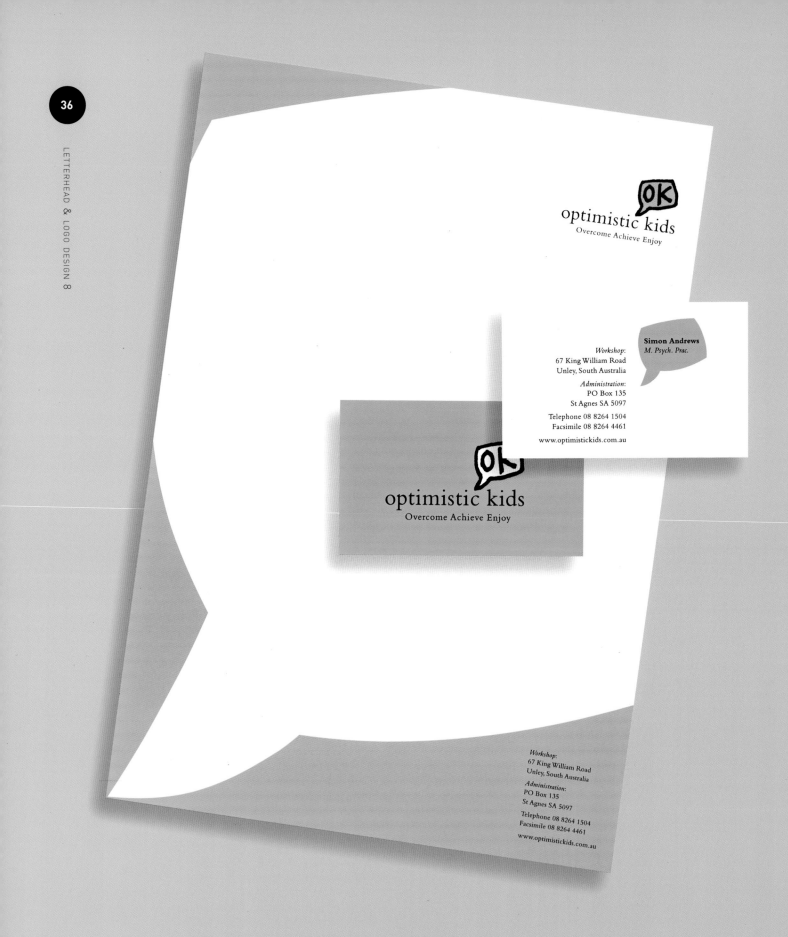

1

CAPITOL TITLE

2

3

1 FRESH BRAND, INC. | ART DIRECTOR MARCEL VENTER | CLIENT CAPITAL TITLE

2 FUSZION COLLABORATIVE | ART DIRECTOR TONY FLETCHER | DESIGNERS TONY FLETCHER, EMILY CARR | CLIENT PROPEL VENTURES

3 PAPER HAT DESIGN WORKS | DESIGNER TOM LYONS | CLIENT FOUR PRODUCTION SOLUTIONS

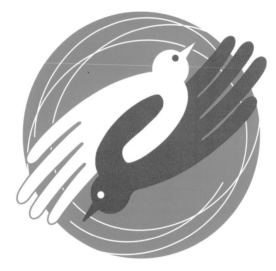

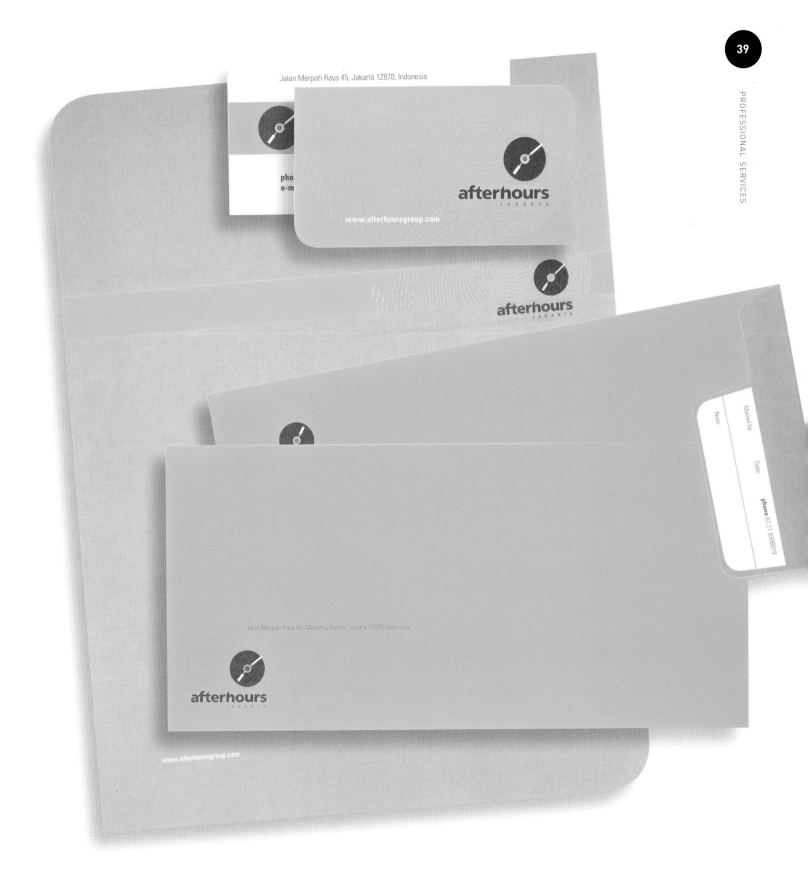

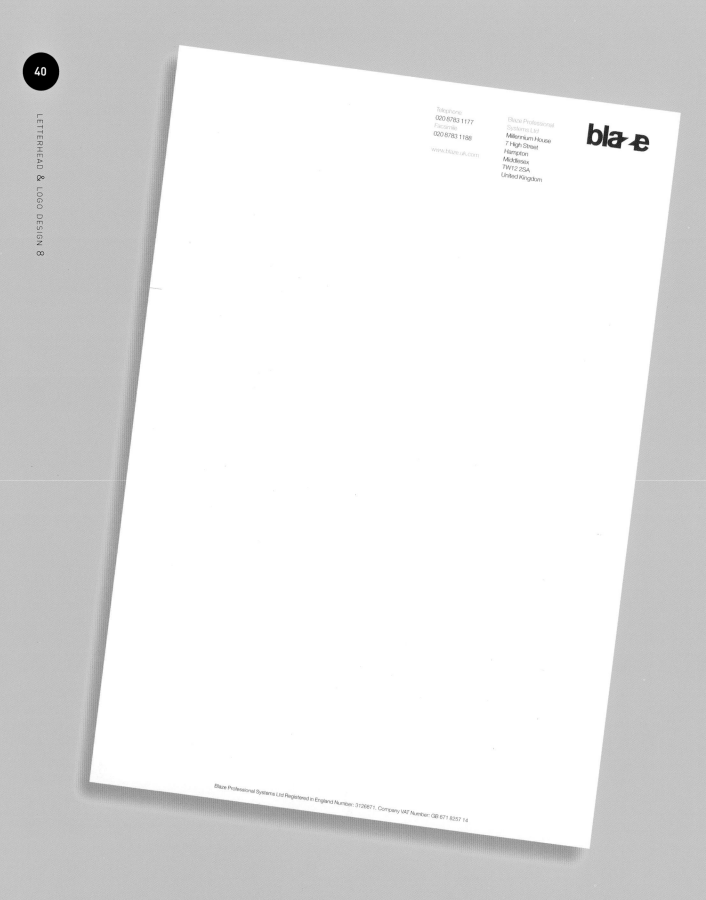

Telephone
020 8783 1177
Facsimile
020 8783 1188

www.blaze.uk.com

Blaze Professional
Systems Ltd
Millennium House
7 High Street
Hampton
Middlesex
TW12 2SA
United Kingdom

bla e

Blaze Professional Systems Ltd Registered in England Number: 3126871. Company VAT Number: GB 671 8257 14

WILSON HARVEY | ART DIRECTOR **DANIEL ELLIOTT** | CLIENT **BLAZE SYSTEMS**

DANIEL ELLIOTT | ART DIRECTOR **DANIEL ELLIOTT** | CLIENT **BLAZE SYSTEMS**

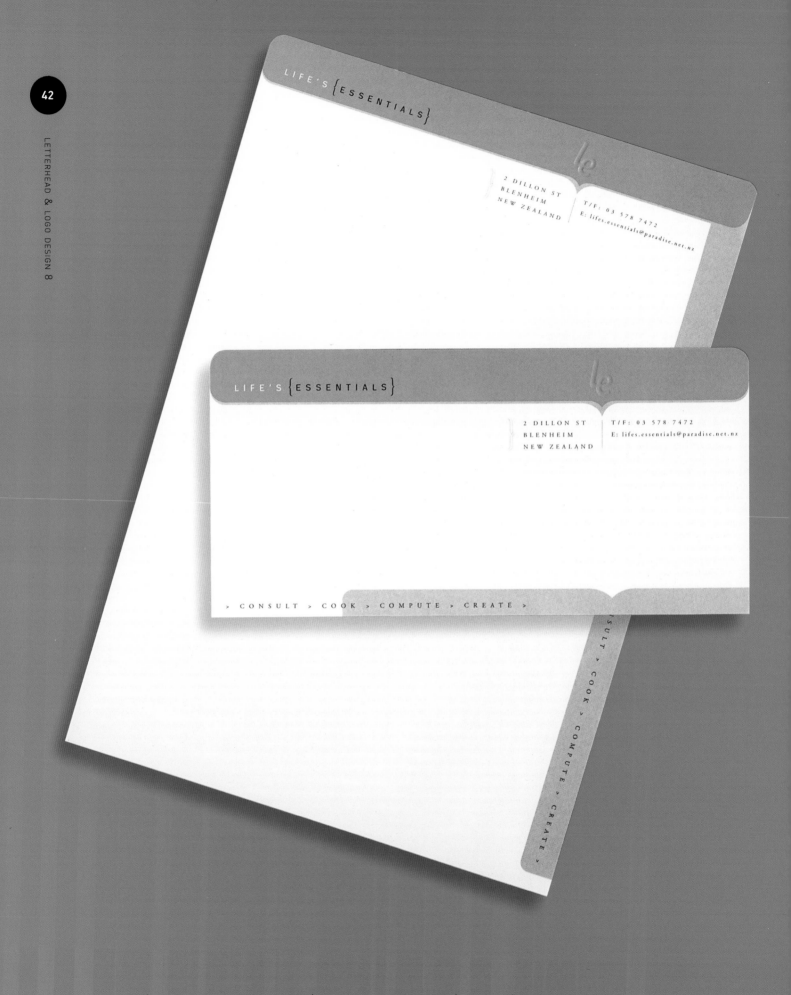

LLOYD'S GRAPHIC DESIGN AND COMMUNICATION | ART DIRECTOR ALEXANDER LLOYD | CLIENT LIFE'S ESSENTIALS

1

FRESHBRAND

2

3

PARADIGM

PUBLISHING GROUP

4

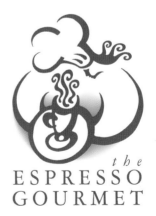

the
ESPRESSO
GOURMET

1 FRESHBRAND, INC. | ART DIRECTOR MARCEL VENTER | CLIENT FRESHBRAND

2 YES DESIGN | ART DIRECTOR YVONNE SAKOWSKI | CLIENT REZAW-PLAST

3 GASKET | ART DIRECTOR MIKE CHRISTOFFEL | DESIGNERS MIKE CHRISTOFFEL, TODD HANSSON | CLIENT FIONA TUCKER

4 MORRIS CREATIVE INC. | ART DIRECTOR STEVEN MORRIS | CLIENT ESPRESSO GOURMET

1

2

3

4

1 **LOVE COMMUNICATIONS** | ART DIRECTOR **PRESTON WOOD** | DESIGNERS **CRAIG LEE, PRESTON WOOD** | CLIENT **CRAIG LEE**

2 **UP DESIGN BUREAU** | ART DIRECTOR **TRAVIS BROWN** | CLIENT **CHRISTY PETERS**

3 **IRIDIUM, A DESIGN AGENCY** | ART DIRECTOR **MARIO L'ECUYER** | CLIENT **NEXWAVE CORPORATION**

4 **CATO PURNELL PARTNERS** | ART DIRECTOR **CATO PURNELL PARTNERS** | CLIENT **INFRATILE**

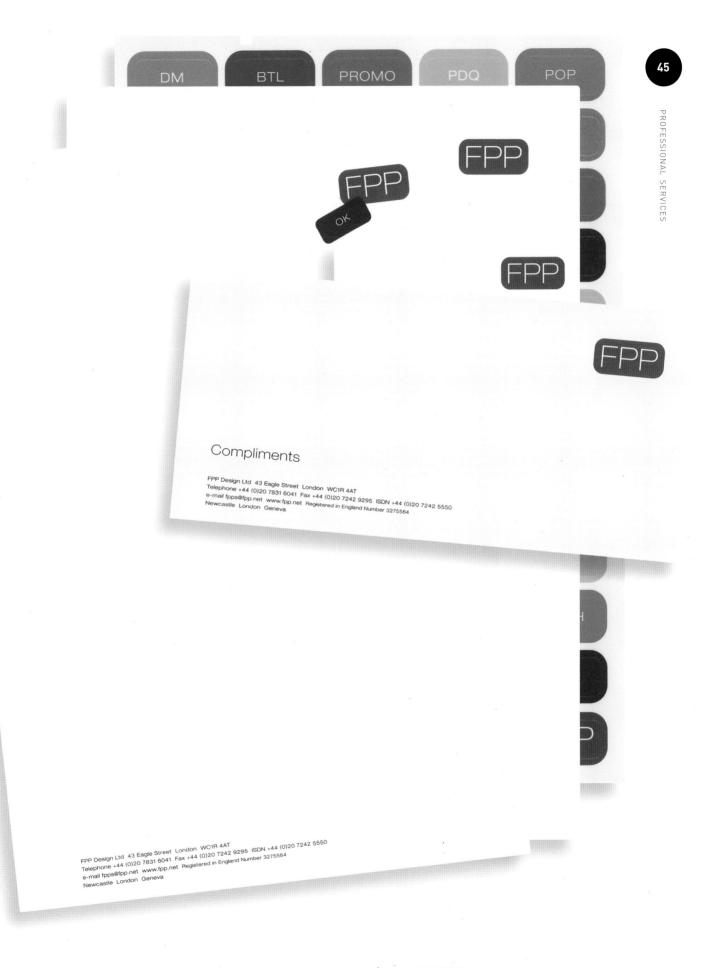

DM BTL PROMO PDQ POP

FPP

FPP

OK

FPP

FPP

Compliments

FPP Design Ltd 43 Eagle Street London WC1R 4AT
Telephone +44 (0)20 7831 6041 Fax +44 (0)20 7242 9295 ISDN +44 (0)20 7242 5550
e-mail fpps@fpp.net www.fpp.net Registered in England Number 3275564
Newcastle London Geneva

FPP Design Ltd 43 Eagle Street London WC1R 4AT
Telephone +44 (0)20 7831 6041 Fax +44 (0)20 7242 9295 ISDN +44 (0)20 7242 5550
e-mail fpps@fpp.net www.fpp.net Registered in England Number 3275564
Newcastle London Geneva

DEW GIBBONS | ART DIRECTOR SHAUN DEW | DESIGNER SINE BR_GGER S_RENSEN | CLIENT FPP DESIGN

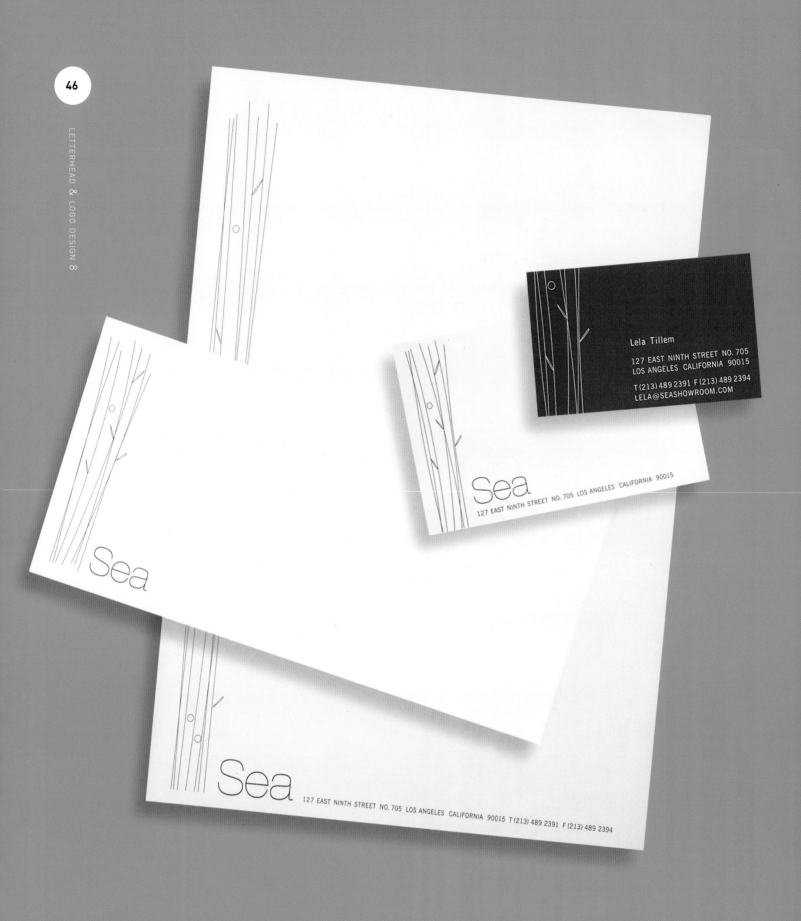

Lela Tillem
127 EAST NINTH STREET NO. 705
LOS ANGELES CALIFORNIA 90015

T (213) 489 2391 F (213) 489 2394
LELA@SEASHOWROOM.COM

Sea
127 EAST NINTH STREET NO. 705 LOS ANGELES CALIFORNIA 90015

Sea
127 EAST NINTH STREET NO. 705 LOS ANGELES CALIFORNIA 90015 T (213) 489 2391 F (213) 489 2394

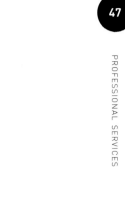

350 CONEJO RIDGE AVENUE THOUSAND OAKS
CALIFORNIA **91361805** 370.5858 **TEL**
▪ ZIP CODE 370.1202 **FAX**

WWW.BLUELABELRECORDS
URL.NET

350 CONEJO RIDGE AVENUE THOUSAND OAKS
CALIFORNIA **91361805** 370.5858 **TEL**
▪ ZIP CODE 370.1202 **FAX**

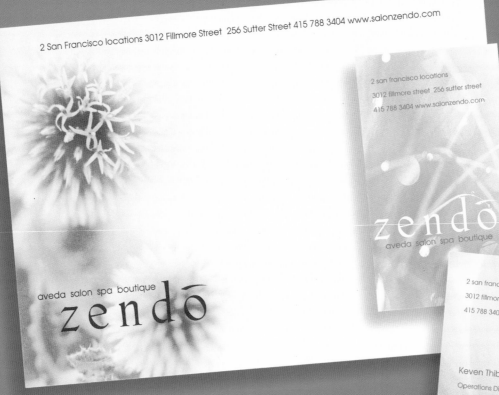

1

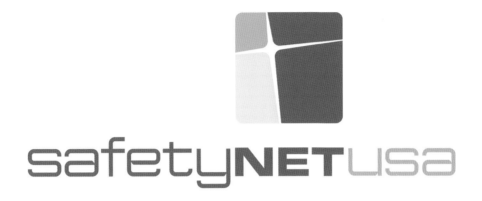

safety**NET**usa

2

replecs
FUTURE OF MESSAGING

3

FUSZION | COLLABORATIVE

1 **FRESHBRAND, INC.** | ART DIRECTOR **MARCEL VENTER** | CLIENT **SAFETYNET USA.COM**
2 **STILRADAR** | ART DIRECTOR **RAPHAEL POHLAND, SIMONE WINTER** | CLIENT **REPLECS AG**
3 **FUSZION COLLABORATIVE** | ART DIRECTORS **RICHARD LEE HEFFNER, TONY FLETCHER** | DESIGNER **TONY FLETCHER** | CLIENT **FUSZION COLLABORATIVE**

1

THINKSPACE

VENTURES BASED ON INTELLIGENT TECHNOLOGY

2

3

1 **HONEY DESIGN** | ART DIRECTOR **ROBIN HONEY** | DESIGNER **JASON RECKER** | CLIENT **THINK SPACE**

2 **PACEY + PACEY** | ART DIRECTOR **ROBERT PACEY** | DESIGNER **MICHAEL PACEY** | CLIENT **JUST ASK!**

3 **RED STUDIOS** | ART DIRECTOR **RUBEN ESPARZA** | CLIENT **DEAN LARKEN DESIGN ARCHITECTS**

colleen o'mara
5225 wilshire blvd
suite 403
los angeles, ca 90036

tel 323 938 8363
fax 323 938 8757
colleen@hypeworld.com

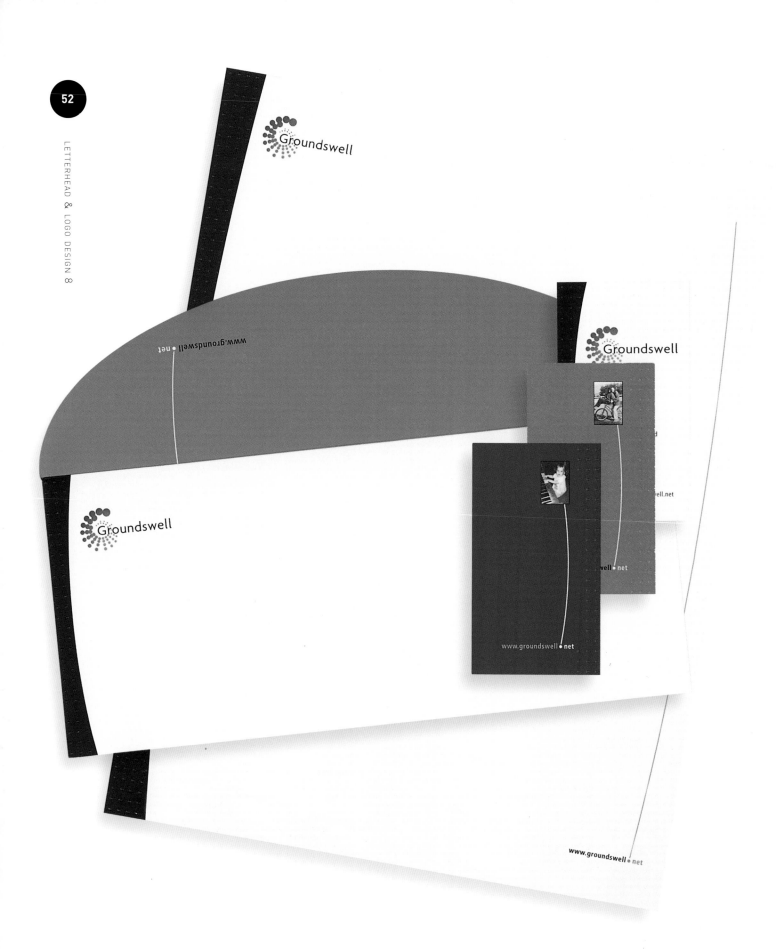

FINELINES

77 Walnut Street Unit 8 Peabody Massachusetts 01960 phone 978-977-7357 fax 978-977-7353 www.finelines.com

Pat King Workroom Manager

FINELINES

phone 978-977-7357 ext 103
fax 978-977-7353 www.finelines.com

77 Walnut Street Unit 8 Peabody Massachusetts 01960

FINELINES

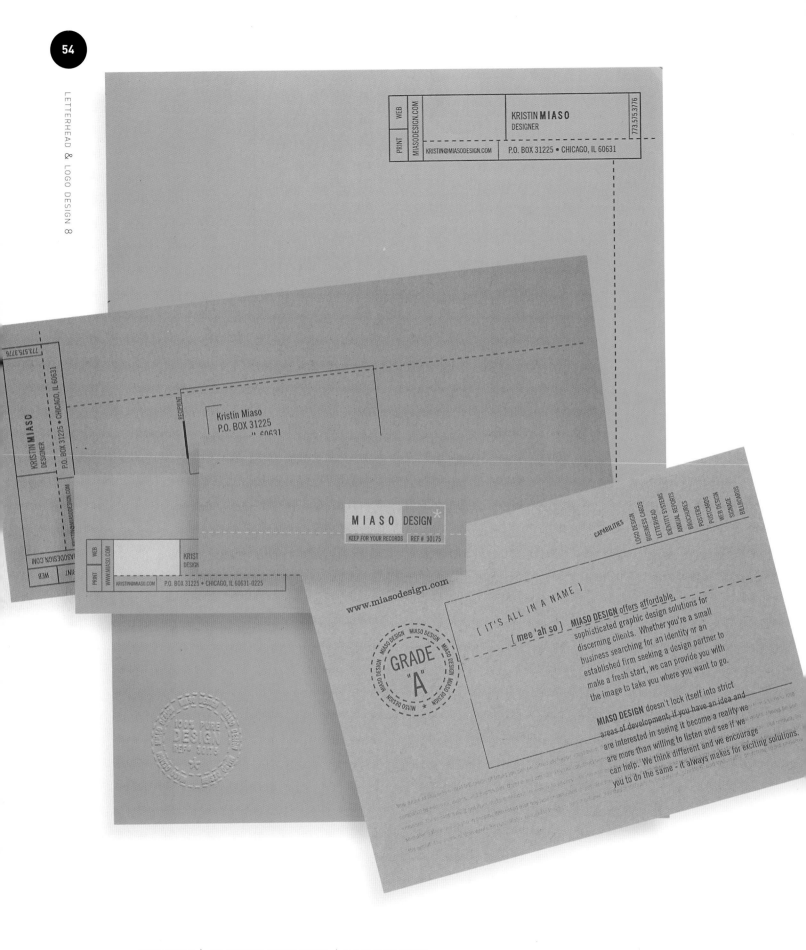

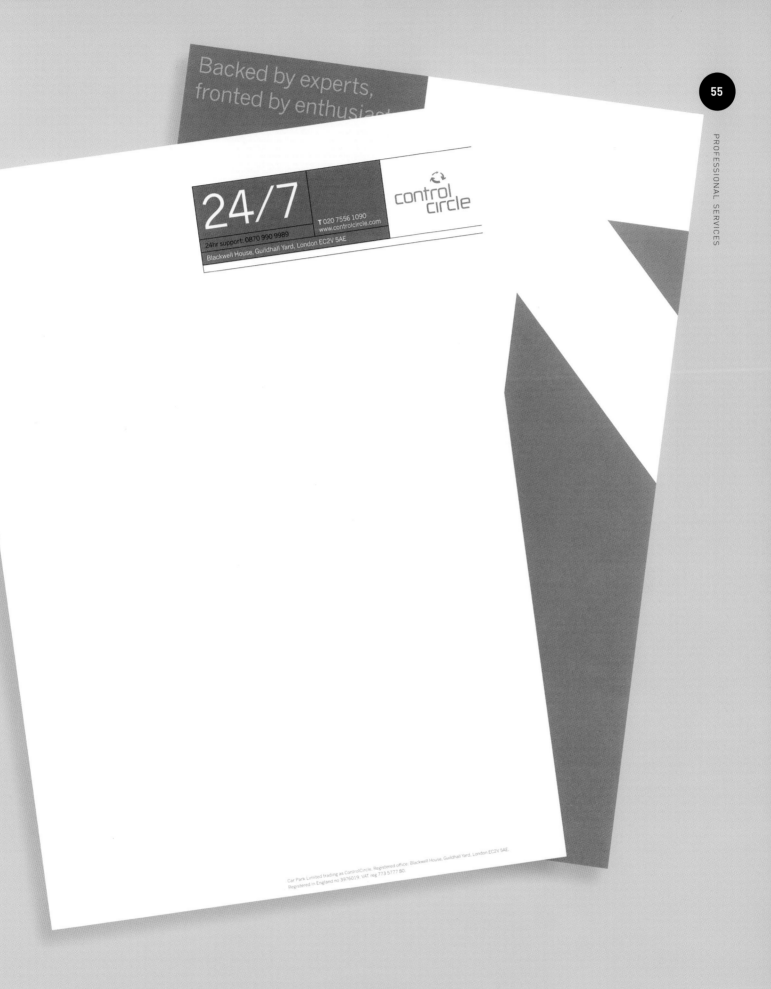

Backed by experts,
fronted by enthusia...

24/7

T 020 7556 1090
www.controlcircle.com

control
circle

24hr support: 0870 990 9989

Blackwell House, Guildhall Yard, London EC2V 5AE.

Car Park Limited trading as ControlCircle. Registered office: Blackwell House, Guildhall Yard, London EC2V 5AE.
Registered in England no 3976019. VAT reg 773 5777 80.

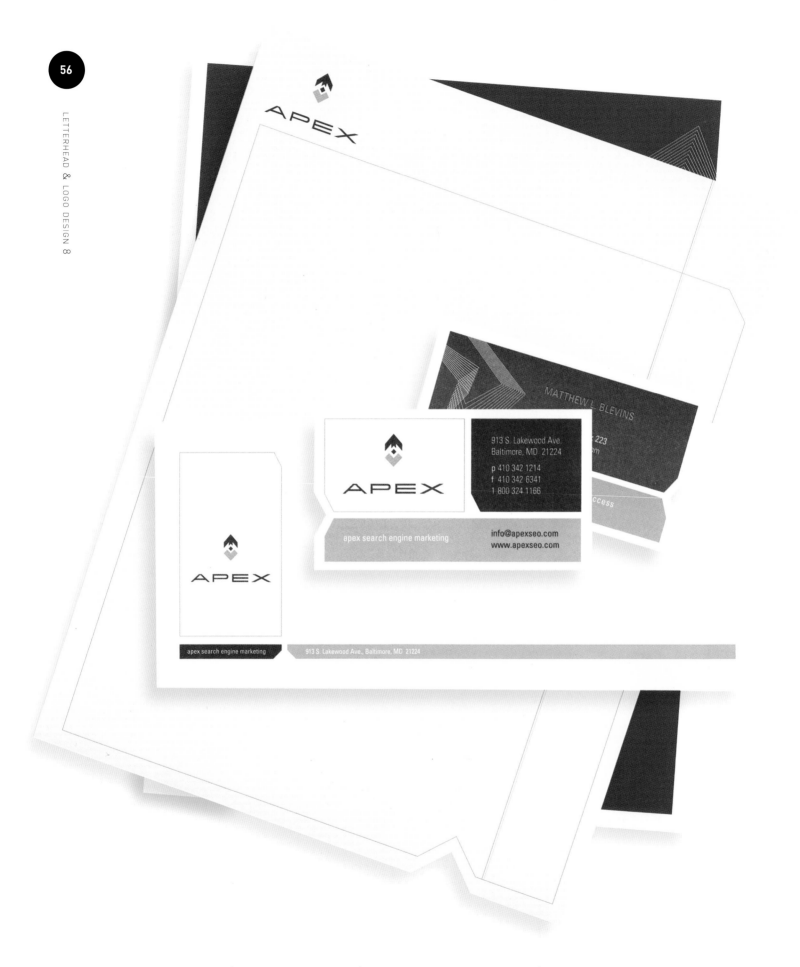

RE: SALZMAN DESIGNS | ART DIRECTOR IDA CHEINMAN | DESIGNERS IDA CHEINMAN, RICK SALZMAN | CLIENT APEX SEO

APEX

RE: SALZMAN DESIGNS | ART DIRECTOR IDA CHEINMAN | DESIGNERS IDA CHEINMAN, RICK SALZMAN | CLIENT APEX SEO

LEERS WEINZAPFEL ASSOCIATES

280 Summer Street
Boston, Massachusetts 02210
T 617.423.5711 **F** 617.482.7257

ARCHITECTS, INC.

Andrea P. Leers FAIA
Jane Weinzapfel FAIA
Josiah Stevenson AIA
Joe F. Pryse AIA

James E. Vogel AIA
Winifred Ann Stopps AIA
Margaret Minor AIA
Alex Adkins AIA
Joe M. Raia AIA
Alexander C. Carroll AIA

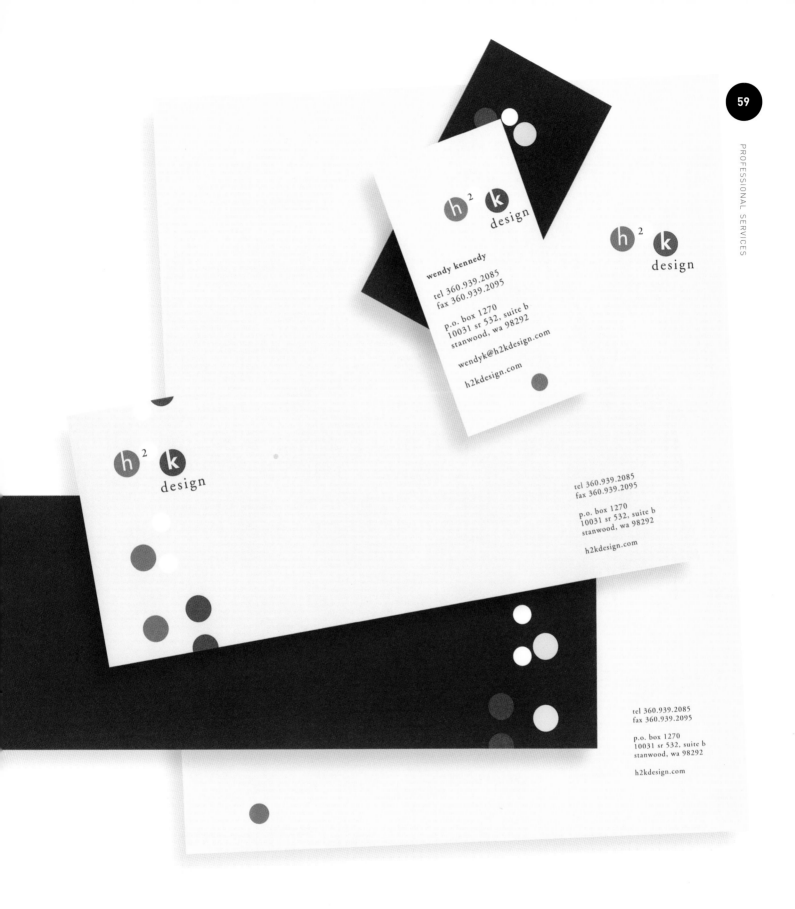

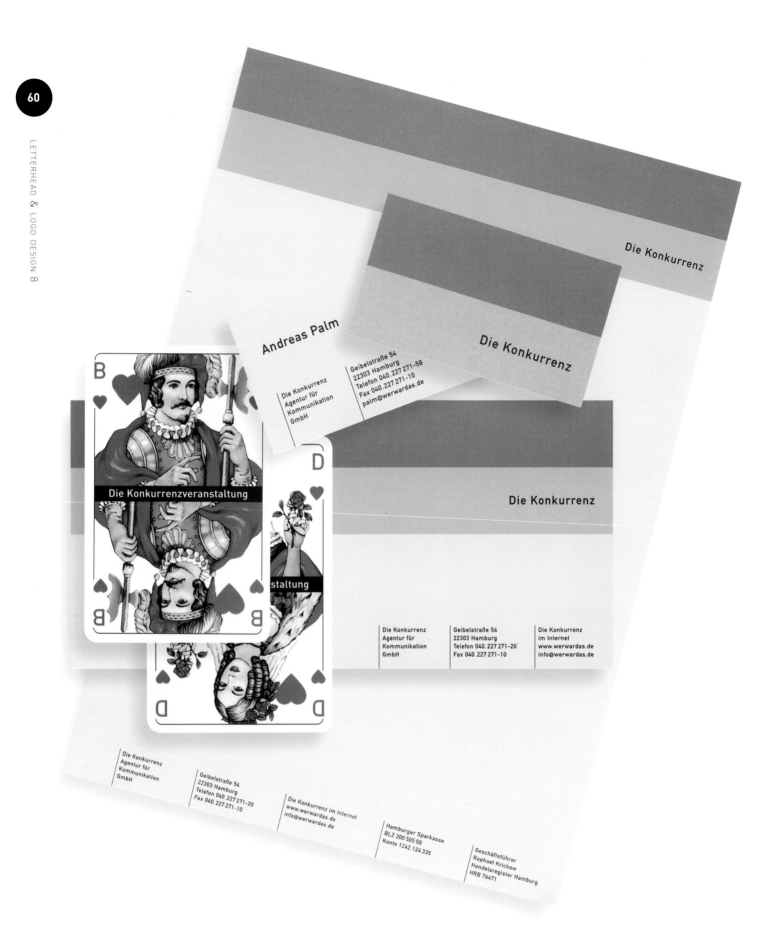

1 **RED STUDIOS** | ART DIRECTOR **RUBEN ESPARZA** | CLIENT **KEVIN STALTER CO.**

2 **IRIDIUM, A DESIGN AGENCY** | ART DIRECTOR **JEAN-LUC DENAT** | CLIENT **MAGPIE COMMUNICATIONS**

3 **ML DESIGN** | CLIENT **DOG'S BEST FRIEND**

ROSTYLE

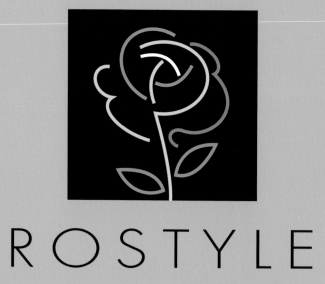

ROSTYLE

TONG DESIGN | ART DIRECTOR **TONG WAI HANG** | CLIENT **TAISHIN INTERNATIONAL BANK**

Scanalog Inc.

385 Farm to M
Brewster.
Tel : 845
Fax : 84

www.

385 Farm to Market Rd. Brewster, NY 10509 | Tel : 845.279.7550 Fax: 845.278.4749
WWW.SCANALOG.COM

THE DIECKS GROUP | ART DIRECTORS MICHAEL WALDRON, BRIAN DIECKS | DESIGNER MICHAEL WALDRON | CLIENT SCANALOG

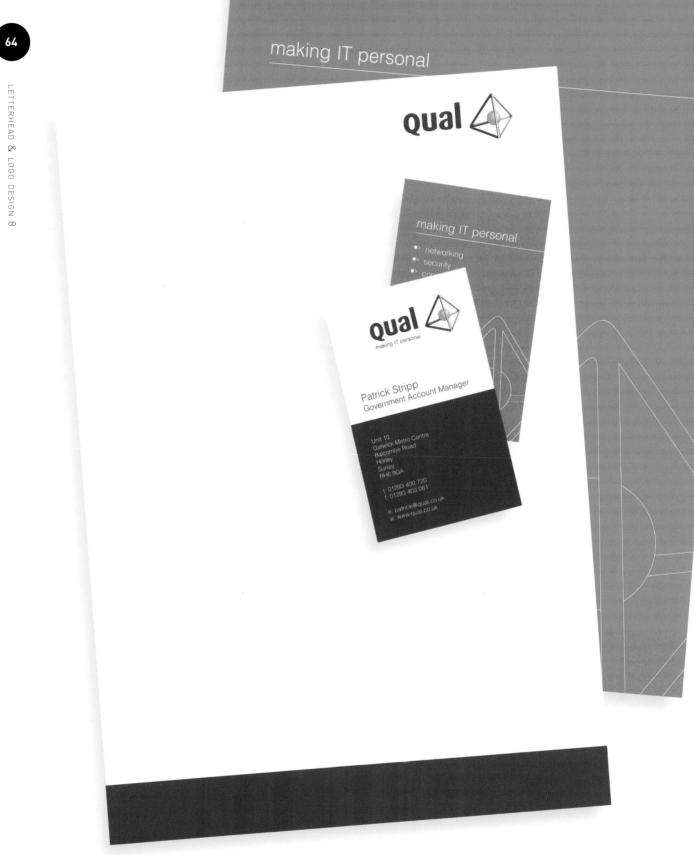

making IT personal

qual

making IT personal

networking
security

qual

making IT personal

Patrick Stripp
Government Account Manager

Unit 10
Gatwick Metro Centre
Balcombe Road
Horley
Surrey
RH6 9GA

t: 01293 400 720
f: 01293 403 061

e: patrick@qual.co.uk
w: www.qual.co.uk

CPD | ART DIRECTOR **NIGEL BEECHY** | DESIGNERS **NIGEL BEECHY, FIONA CATT** | CLIENT **STUDENT DESIGN AWARDS**

MARV LEVEE

Senior Vice President

308 WEST ERIE STREET
SUITE 400
CHICAGO, IL 60610

marvl@italiapartners.com

312.397.4324
312.397.4339

LOS ANGELES DALLAS CHICAGO

308 WEST ERIE STREET
SUITE 400
CHICAGO, IL 60610

LOS ANGELES DALLAS CHICAGO

308 WEST ERIE STREET SUITE 400 CHICAGO, IL 60610 312.397.9999 312.397.4339 italiapartners@com

LOS ANGELES DALLAS CHICAGO

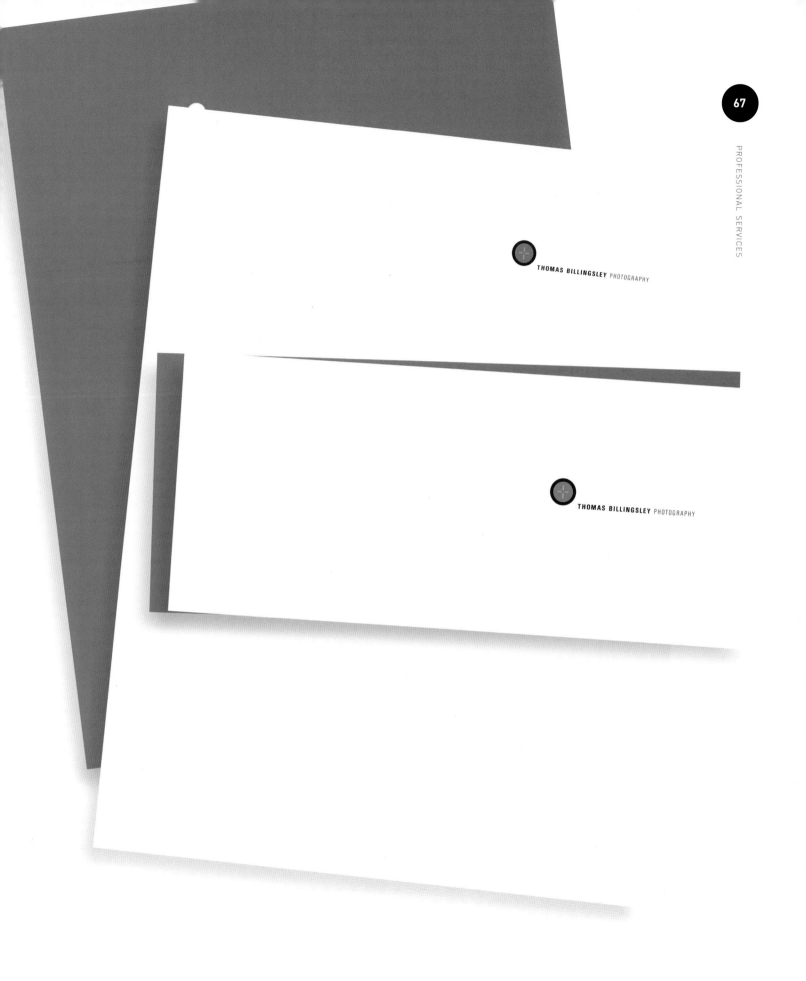

THOMAS BILLINGSLEY PHOTOGRAPHY

THOMAS BILLINGSLEY PHOTOGRAPHY

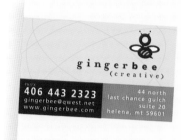

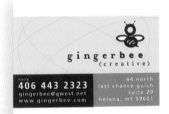

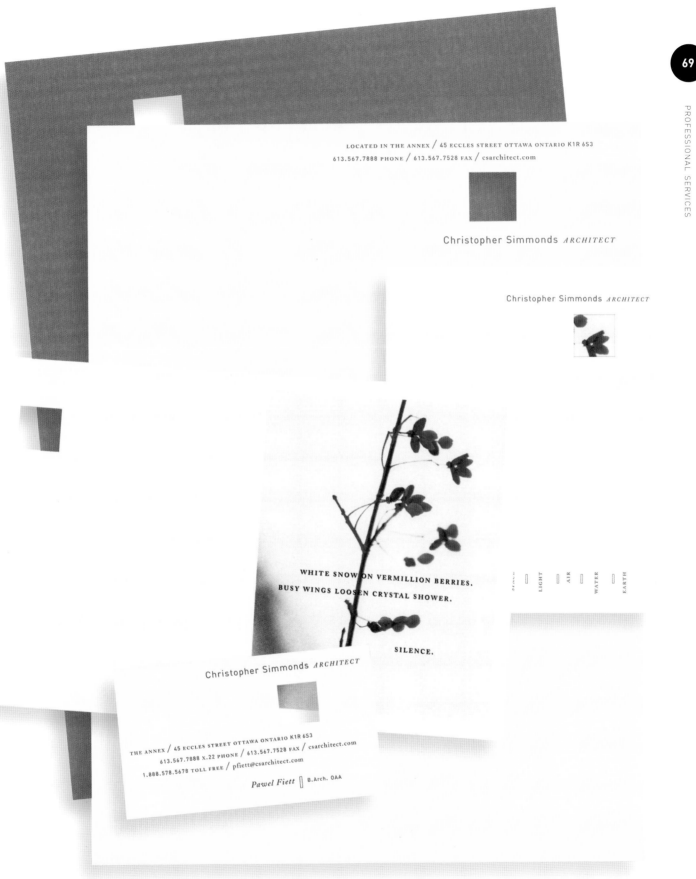

LOCATED IN THE ANNEX / 45 ECCLES STREET OTTAWA ONTARIO K1R 6S3

613.567.7888 PHONE / 613.567.7528 FAX / csarchitect.com

Christopher Simmonds *ARCHITECT*

Christopher Simmonds *ARCHITECT*

WHITE SNOW ON VERMILLION BERRIES.
BUSY WINGS LOOSEN CRYSTAL SHOWER.

SILENCE.

LIGHT AIR WATER EARTH

Christopher Simmonds *ARCHITECT*

THE ANNEX / 45 ECCLES STREET OTTAWA ONTARIO K1R 6S3

613.567.7888 X.22 PHONE / 613.567.7528 FAX / csarchitect.com

1.888.578.5678 TOLL FREE / pfiett@csarchitect.com

Pawel Fiett | B.Arch. OAA

IRIDIUM, A DESIGN AGENCY | ART DIRECTORS JEAN-LUC DENAT, MARIO L'ECUYER | DESIGNER MARIO L'ECUYER | CLIENT CHRISTOPHER SIMMONDS

1

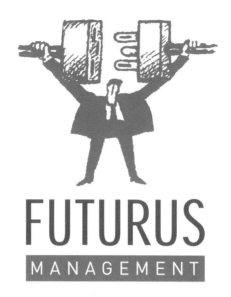

2

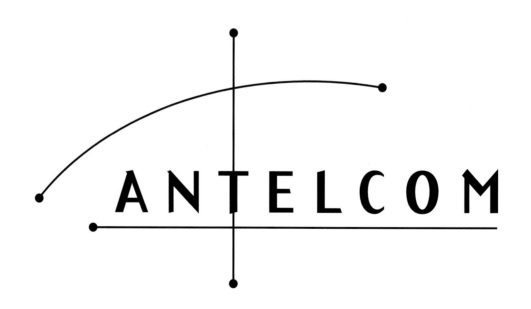

1 REACTOR ART + DESIGN | DESIGNERS PEBBLES CORREA, JERZY KOLACZ | CLIENT FUTURUS MANAGEMENT
2 MARC-ANTOINE HERRMANN | CLIENT ANTELCOMM

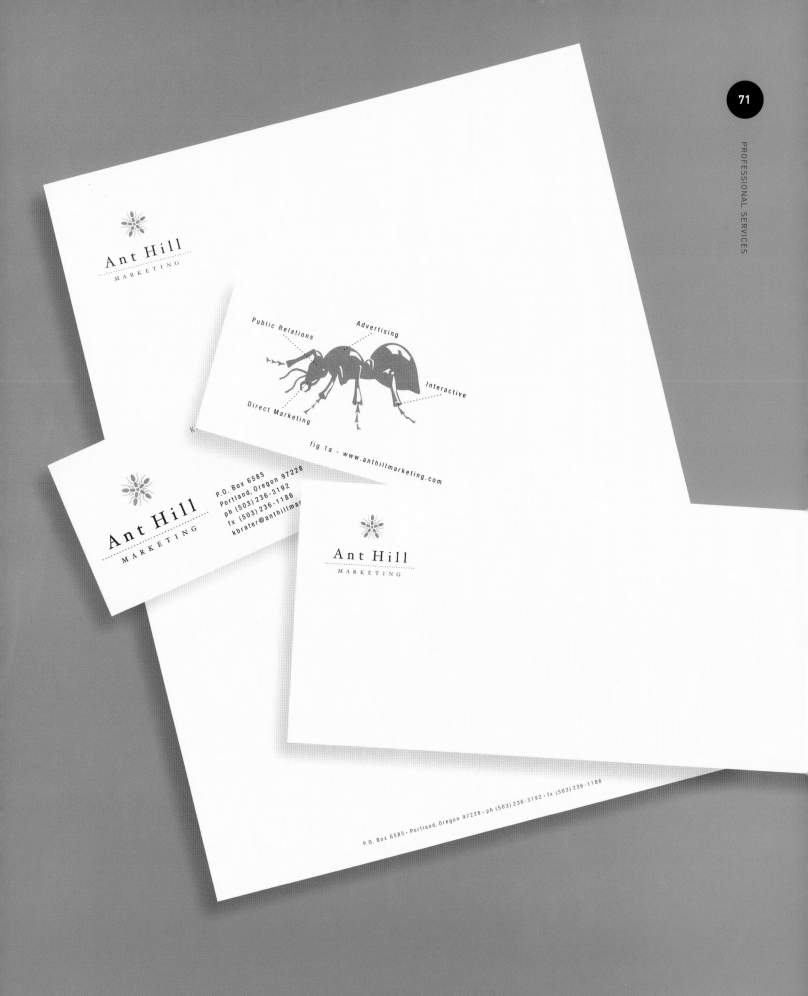

Ant Hill
MARKETING

Public Relations Advertising

Direct Marketing Interactive

fig 1a - www.anthillmarketing.com

Ant Hill
MARKETING

P.O. Box 6585
Portland, Oregon 97228
ph (503) 236-3192
fx (503) 236-1186
kbrater@anthillmar

Ant Hill
MARKETING

P.O. Box 6585 · Portland, Oregon 97228 · ph (503) 236-3192 · fx (503) 236-1186

PURE DESIGN INC. | ART DIRECTOR JOHN FISHER | CLIENT ANT HILL MARKETING

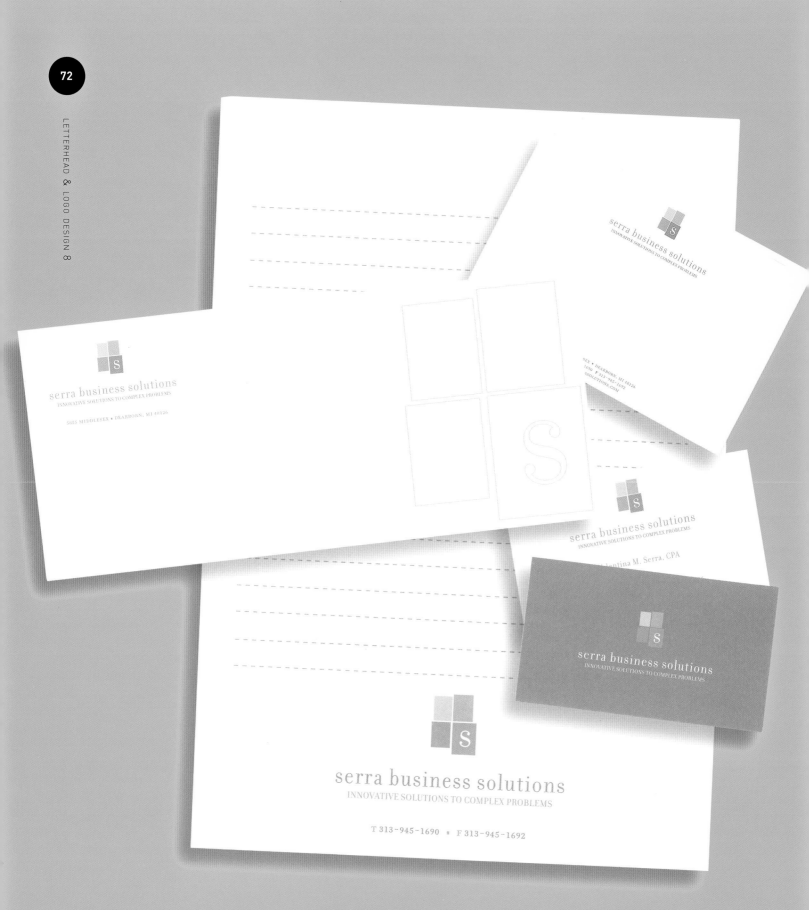

serra business solutions
INNOVATIVE SOLUTIONS TO COMPLEX PROBLEMS

5855 MIDDLESEX • DEARBORN, MI 48126

serra business solutions
INNOVATIVE SOLUTIONS TO COMPLEX PROBLEMS

serra business solutions
INNOVATIVE SOLUTIONS TO COMPLEX PROBLEMS

serra business solutions
INNOVATIVE SOLUTIONS TO COMPLEX PROBLEMS

T 313-945-1690 • F 313-945-1692

The Kenwood Group

The Kenwood Group 75 Varney Place, San Francisco, CA 94107 Tel 415 957-5333

The Kenwood Group

75 Varney Place
San Francisco, CA 94107
Tel 415 957-5333
Fax 415 957-5311

75 Varney Place, San Francisco, CA 94107 Tel 415 957-5333 Fax 415 957-5311 www.kenwoodgroup.com

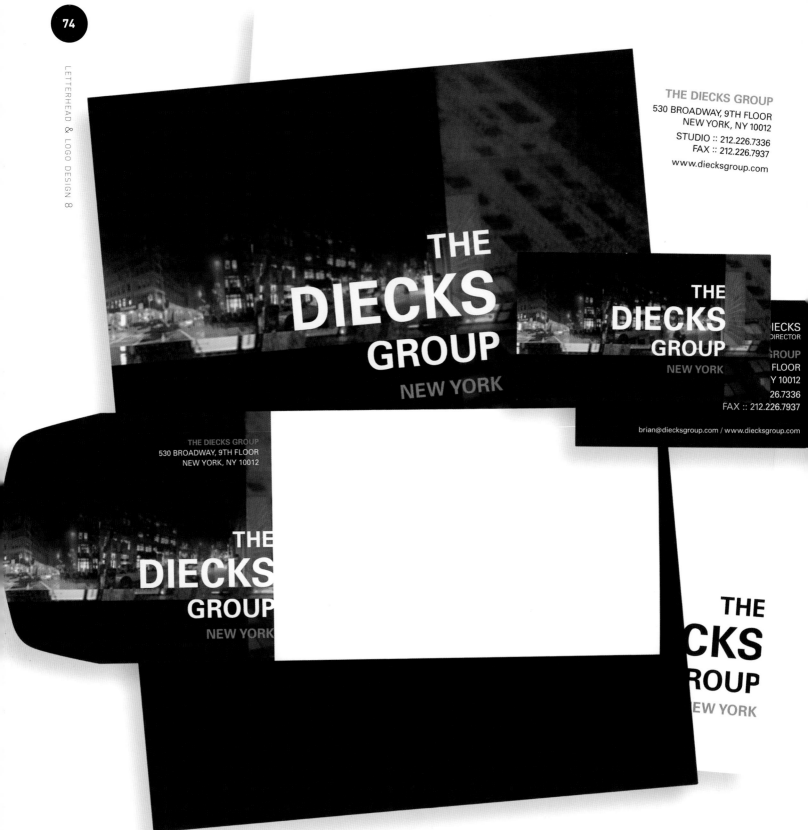

THE DIECKS GROUP
530 BROADWAY, 9TH FLOOR
NEW YORK, NY 10012

STUDIO :: 212.226.7336
FAX :: 212.226.7937

www.diecksgroup.com

THE
DIECKS
GROUP
NEW YORK

THE DIECKS GROUP
530 BROADWAY, 9TH FLOOR
NEW YORK, NY 10012

brian@diecksgroup.com / www.diecksgroup.com

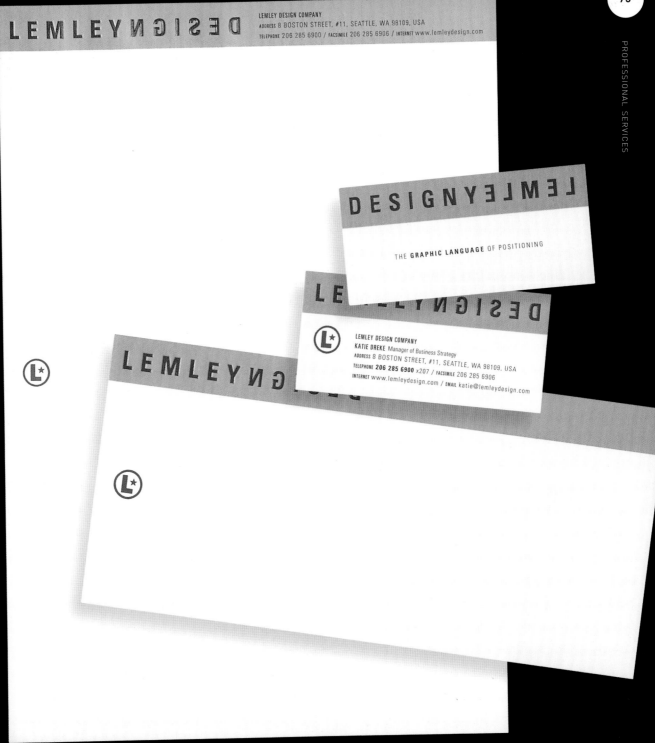

LEMLEY DESIGN COMPANY
ADDRESS 8 BOSTON STREET, #11, SEATTLE, WA 98109, USA
TELEPHONE 206 285 6900 / FACSIMILE 206 285 6906 / INTERNET www.lemleydesign.com

THE **GRAPHIC LANGUAGE** OF POSITIONING

LEMLEY DESIGN COMPANY
KATIE DREKE Manager of Business Strategy
ADDRESS 8 BOSTON STREET, #11, SEATTLE, WA 98109, USA
TELEPHONE **206 285 6900** x207 / FACSIMILE 206 285 6906
INTERNET www.lemleydesign.com / EMAIL katie@lemleydesign.com

LEMELY DESIGN CO. | ART DIRECTOR **DAVID LEMLEY** | CLIENT **LEMLEY DESIGN**

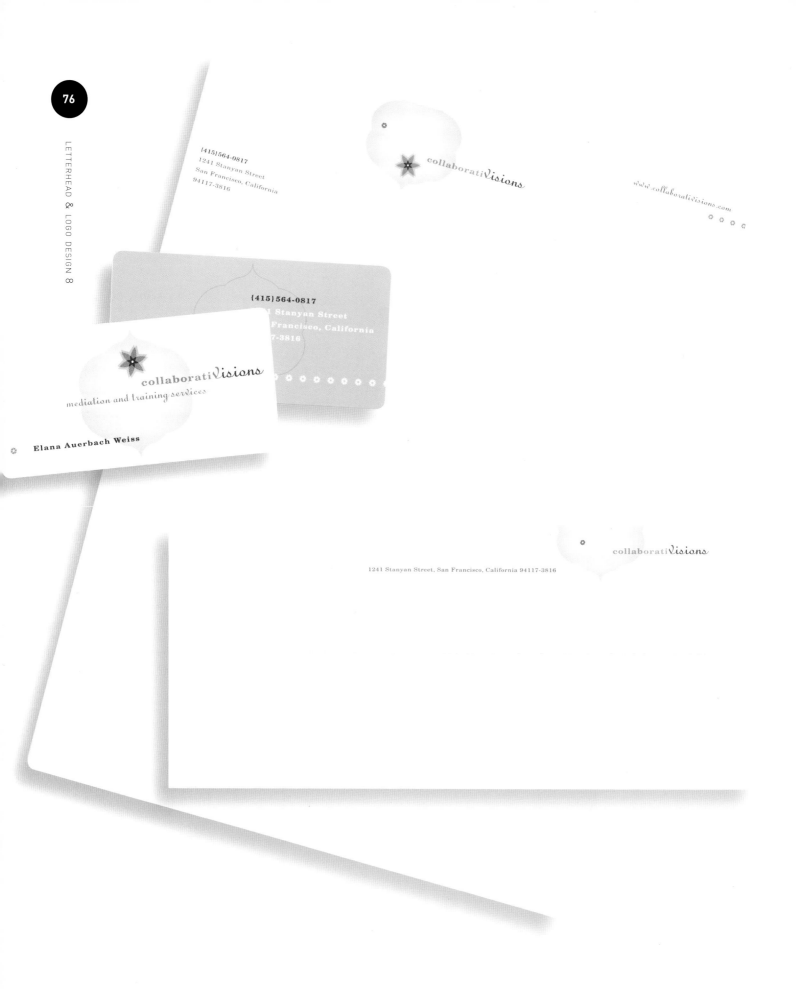

{415}564-0817
1241 Stanyan Street
San Francisco, California
94117-3816

collaboratiVisions

www.collaborativisions.com

{415}564-0817
Stanyan Street
Francisco, California
7-3816

collaboratiVisions
mediation and training services

Elana Auerbach Weiss

collaboratiVisions

1241 Stanyan Street, San Francisco, California 94117-3816

CHEN DESIGN ASSOCIATES | ART DIRECTOR JOSHUA CHEN | DESIGNER MAX SPECTOR | CLIENT COLLABORATIVISIONS

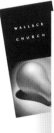

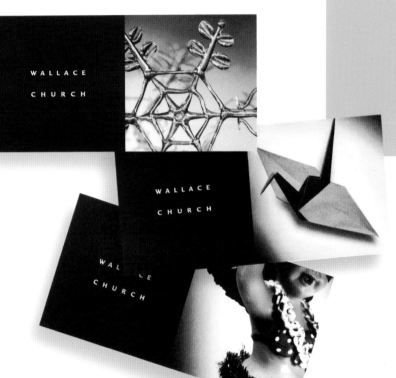

Wallace Church, Inc.
Strategic Brand Identity
330 East 48th Street
New York, NY 10017
212 755 2903

Wallace Church, Inc.
Strategic Brand Identity
330 East 48th Street
New York, NY 10017
T 212 755 2903
F 212 355 6872
www.wallacechurch.com

1

2

1 GOTT FOLK McCANN-ERIKSON | ART DIRECTOR EINAR GYLFASON | CLIENT SISSA PHOTOGRAPHY SCHOOL
2 LEWIS COMMUNICATIONS | ART DIRECTOR ROBERT FROEDGE | CLIENT STAGE POST VIDEO AND POST

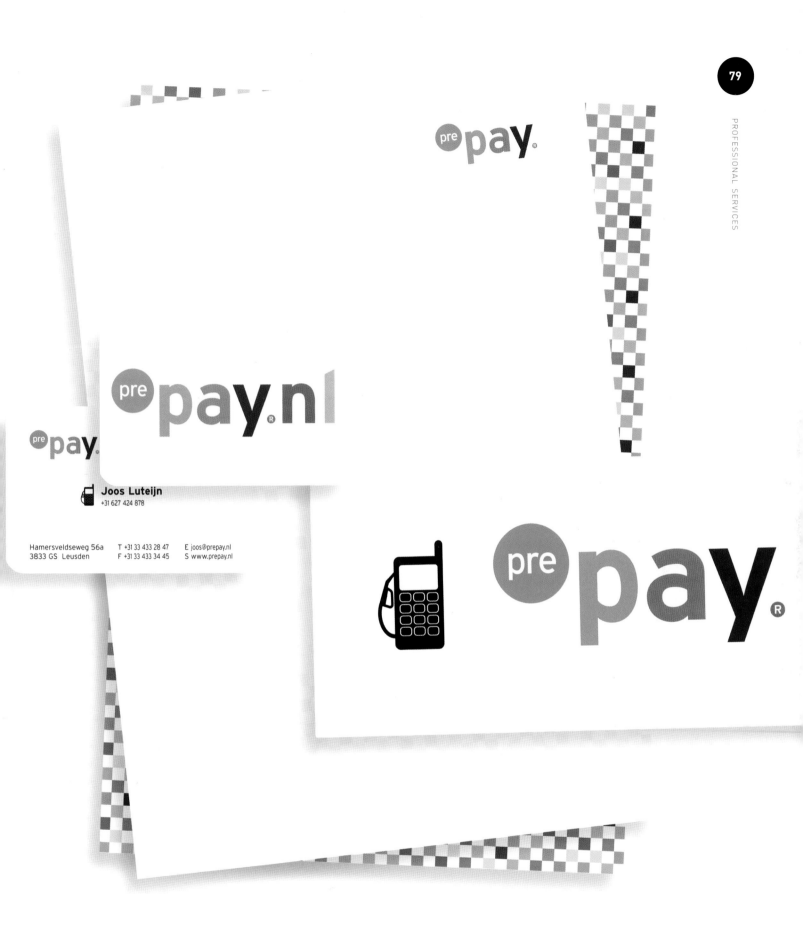

Joos Luteijn
+31 627 424 878

Hamersveldseweg 56a T +31 33 433 28 47 E joos@prepay.nl
3833 GS Leusden F +31 33 433 34 45 S www.prepay.nl

CREATIVE SERVICES

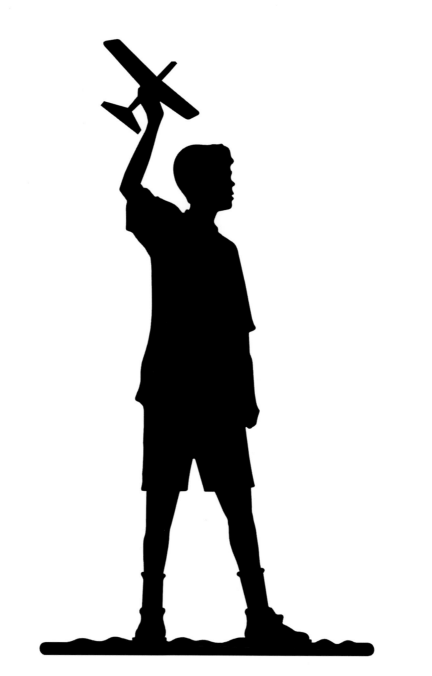

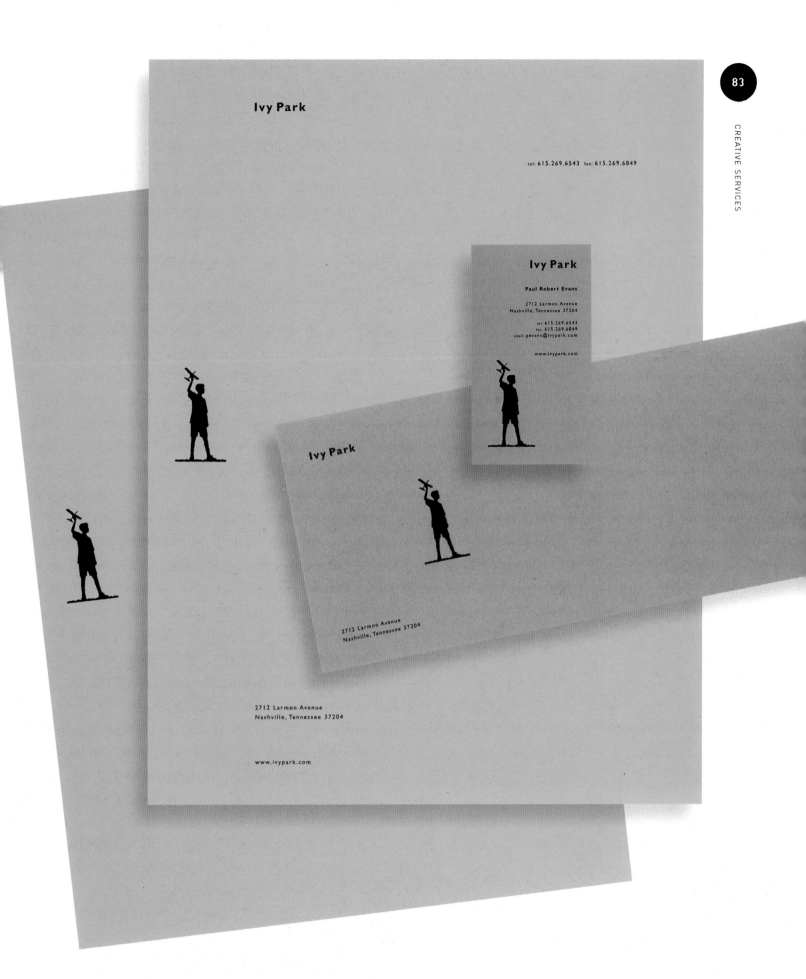

Ivy Park

tel: 615.269.6543 fax: 615.269.6849

Ivy Park

Paul Robert Evans

2712 Larmon Avenue
Nashville, Tennessee 37204

tel: 615.269.6543
fax: 615.269.6849
email: pevans@ivypark.com

www.ivypark.com

Ivy Park

2712 Larmon Avenue
Nashville, Tennessee 37204

2712 Larmon Avenue
Nashville, Tennessee 37204

www.ivypark.com

martinBattarchitects
Martin Batt
39 Wachusett Road
Needham
MA 02492
USA
Telephone 781 444 2747
Fax 781 444 0894
mbatt@martinbatt.com

martinBattarchitects
39 Wachusett Road
Needham
MA 02492
USA
Telephone 781 444 2747
Fax 781 444 0894
martin Batt architects LLC

martinBattarchitects
39 Wachusett Road
Needham
MA 02492
USA
Telephone 781 444 2747
Fax 781 444 0894
www.martinbatt.com

COLOUR:
anne

COLOUR:
parker

COLOUR:
decor

Interior Decorating & Design
Tailored to Suit
Your Home, Your Tastes, Your Budget

JOB No. 016003

PO Box 363, Blenheim · T: 03 577 7567 · F: 03 578 9552 · M: 025 525 302 · E: anne.p@xtra.co.nz

LLOYD'S GRAPHIC DESIGN AND COMMUNICATION | ART DIRECTOR **ALEXANDER LLOYD** | CLIENT **ANNE PARKER**

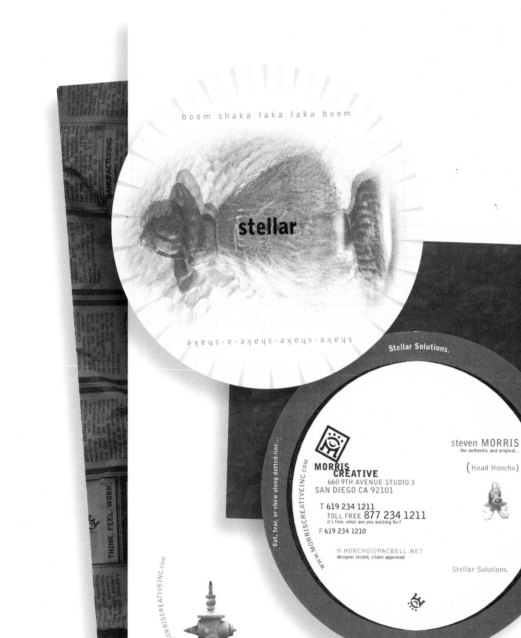

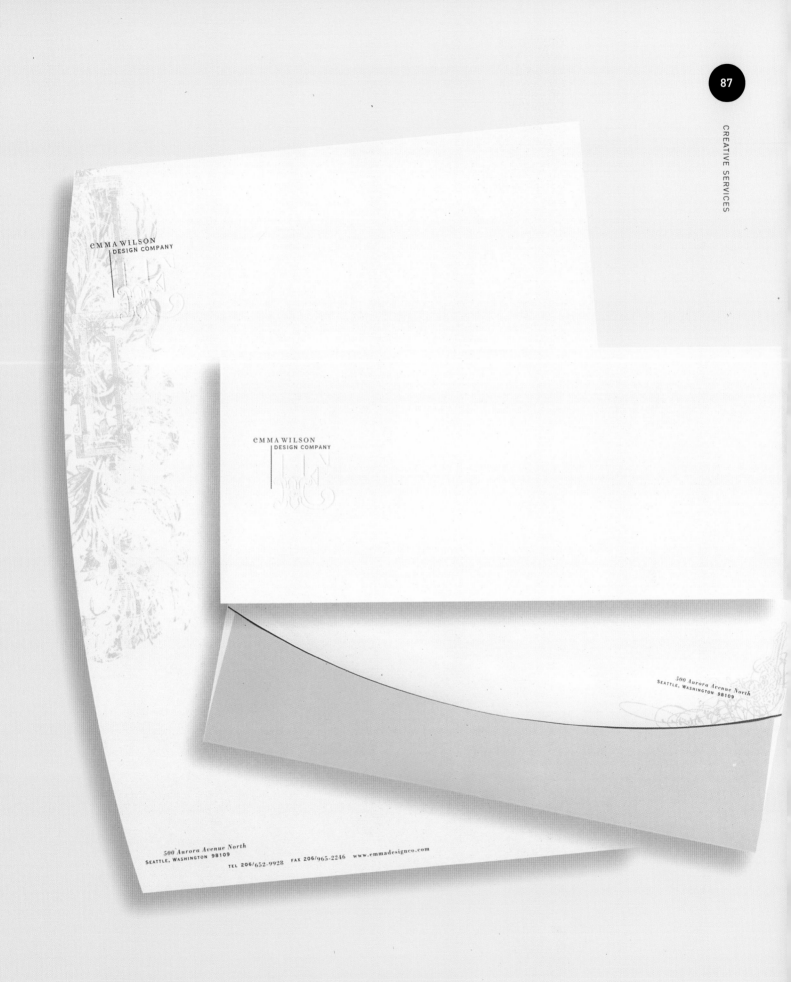

EMMA WILSON DESIGN CO. | DESIGNER **EMMA WILSON** | CLIENT **EMMA WILSON DESIGN CO.**

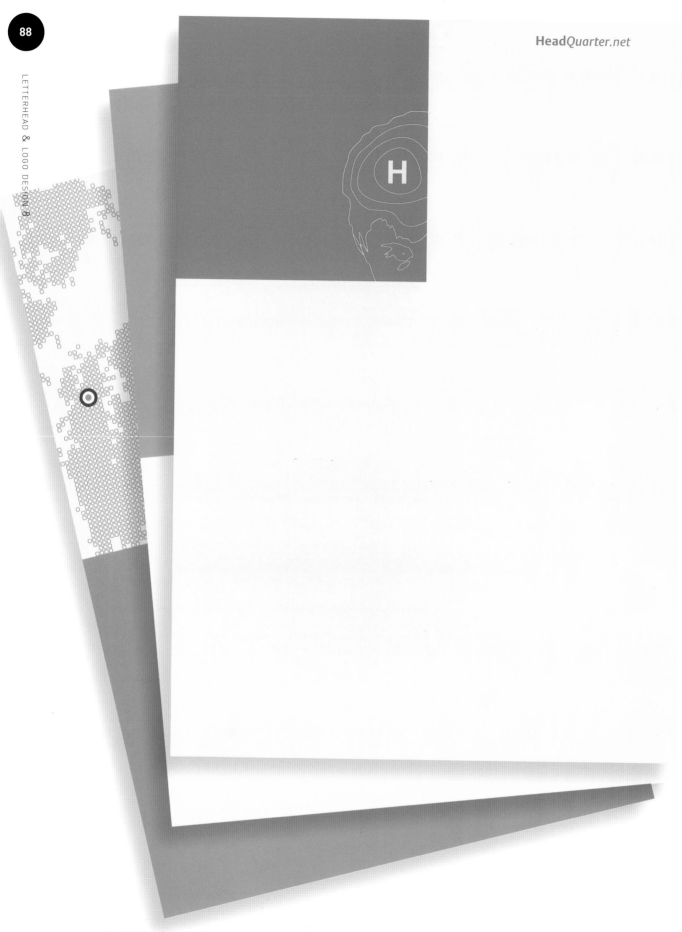

HeadQuarter.net

HEAD QUARTER | ART DIRECTORS MARTIN BOTT, PETER HEINZ | CLIENT OWN LETTERHEAD + CD

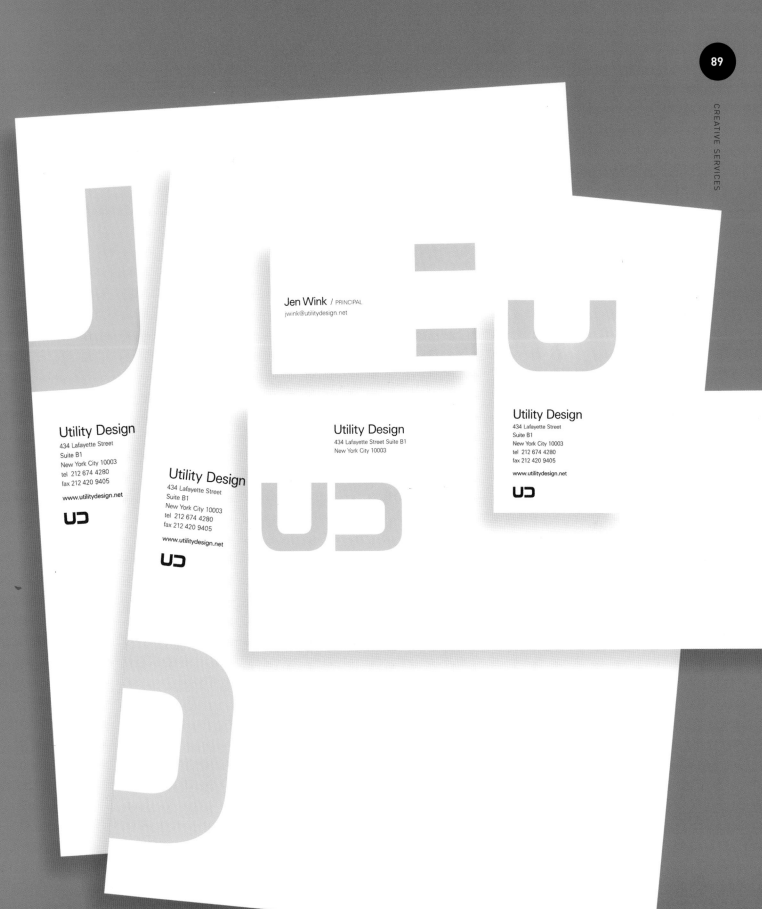

blue

58 old compton street, london W1D 4UF
tel 020 7437 2626 fax 020 7439 2477
www.bluepp.co.uk

blue

blue

blue

blue

58 old compton street,
tel 020 7437 2626 fax

58 old compton street, london W1D 4UF
tel 020 7437 2626 fax 020 7439 2477
www.bluepp.co.uk

blue post production ltd. registered office: 100 fetter lane, london EC4A 1DD. no:2054062

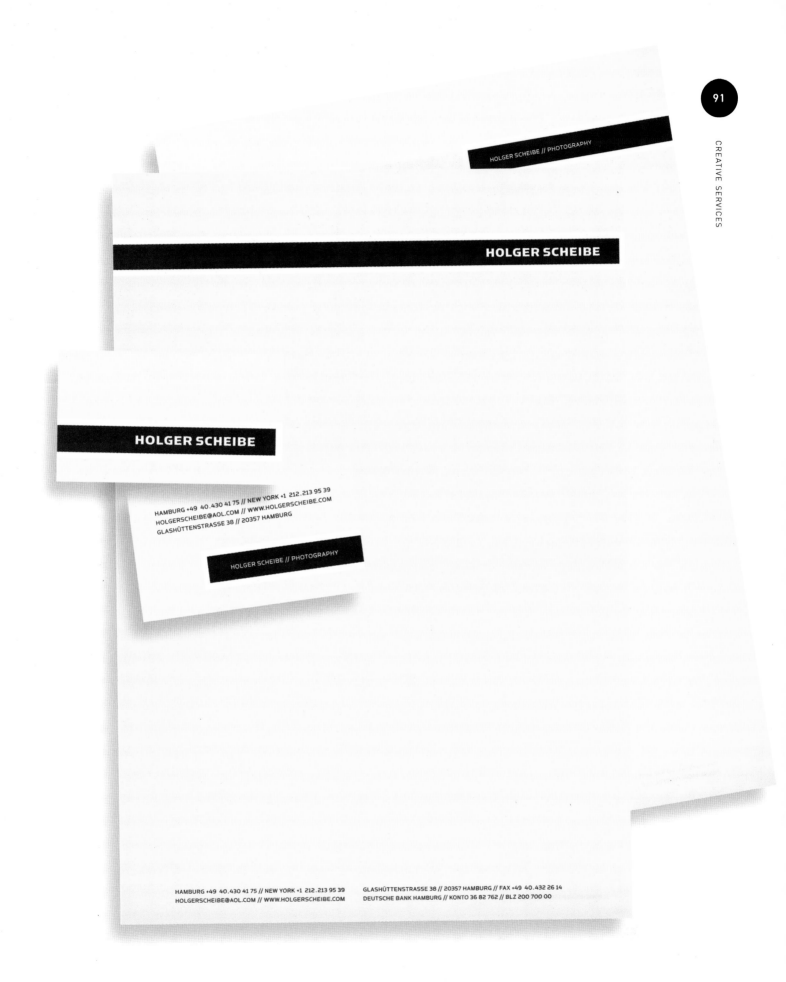

HOLGER SCHEIBE // PHOTOGRAPHY

HOLGER SCHEIBE

HOLGER SCHEIBE

HAMBURG +49 40.430 41 75 // NEW YORK +1 212.213 95 39
HOLGERSCHEIBE@AOL.COM // WWW.HOLGERSCHEIBE.COM
GLASHÜTTENSTRASSE 38 // 20357 HAMBURG

HOLGER SCHEIBE // PHOTOGRAPHY

HAMBURG +49 40.430 41 75 // NEW YORK +1 212.213 95 39 GLASHÜTTENSTRASSE 38 // 20357 HAMBURG // FAX +49 40.432 26 14
HOLGERSCHEIBE@AOL.COM // WWW.HOLGERSCHEIBE.COM DEUTSCHE BANK HAMBURG // KONTO 36 82 762 // BLZ 200 700 00

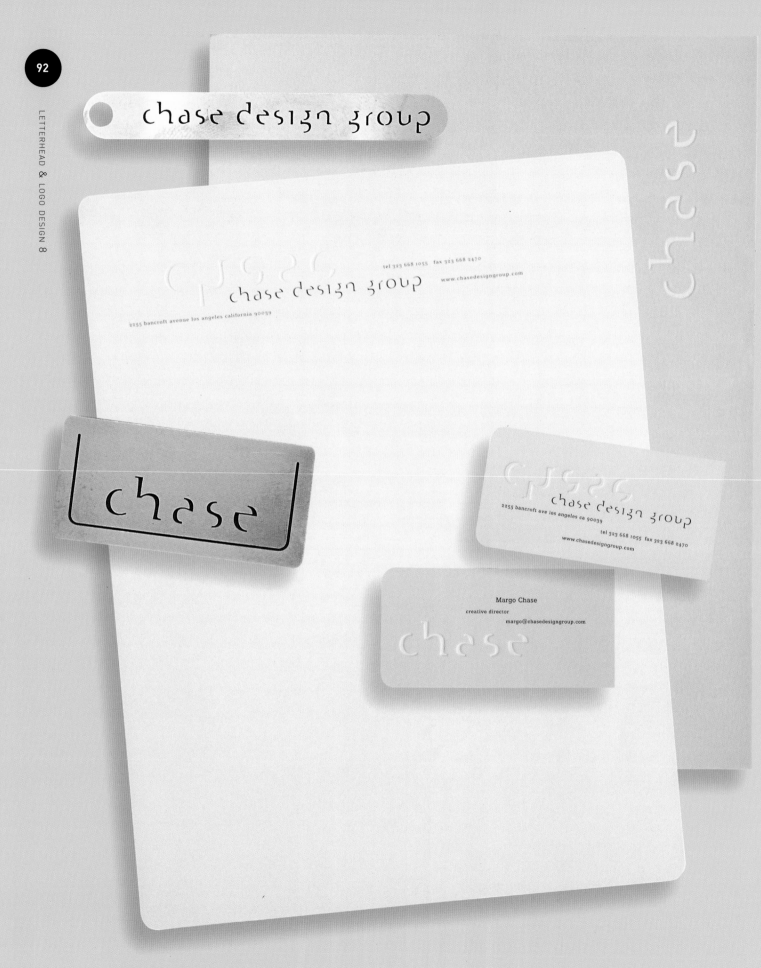

CHASE DESIGN GROUP | ART DIRECTOR **MARGO CHASE** | CLIENT **CHASE DESIGN GROUP**

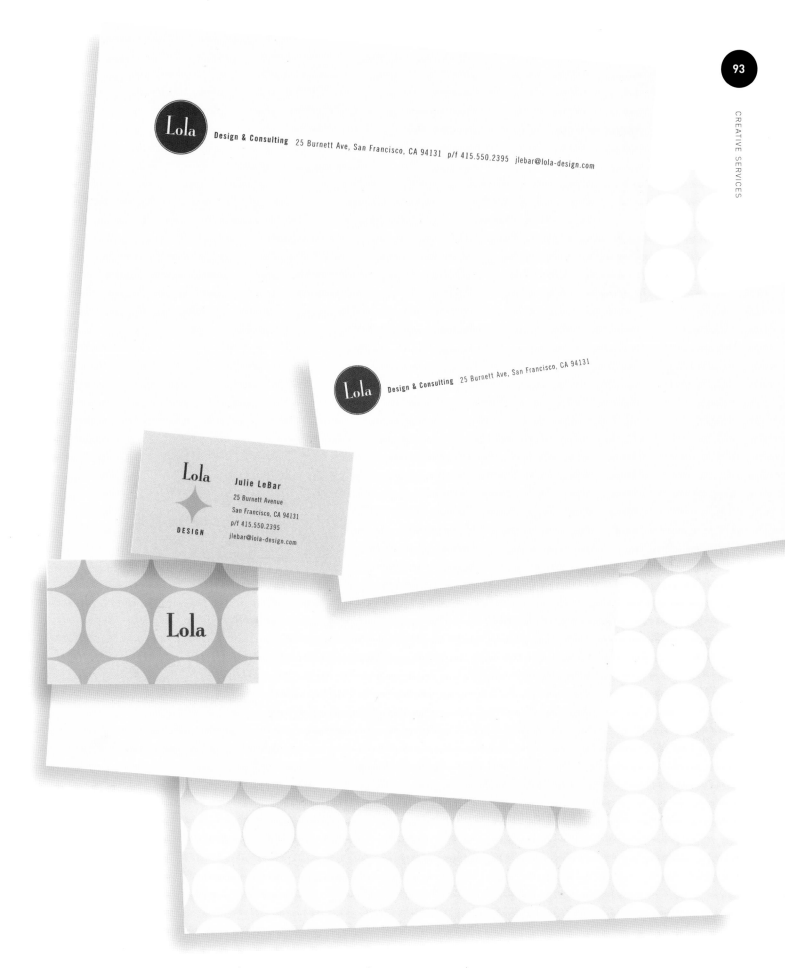

IMAGINE THAT DESIGN STUDIO | ART DIRECTOR **PATTI MANGAN** | DESIGNER **BILL OWEN** | CLIENT **JULIE LEBAR**

PAGE

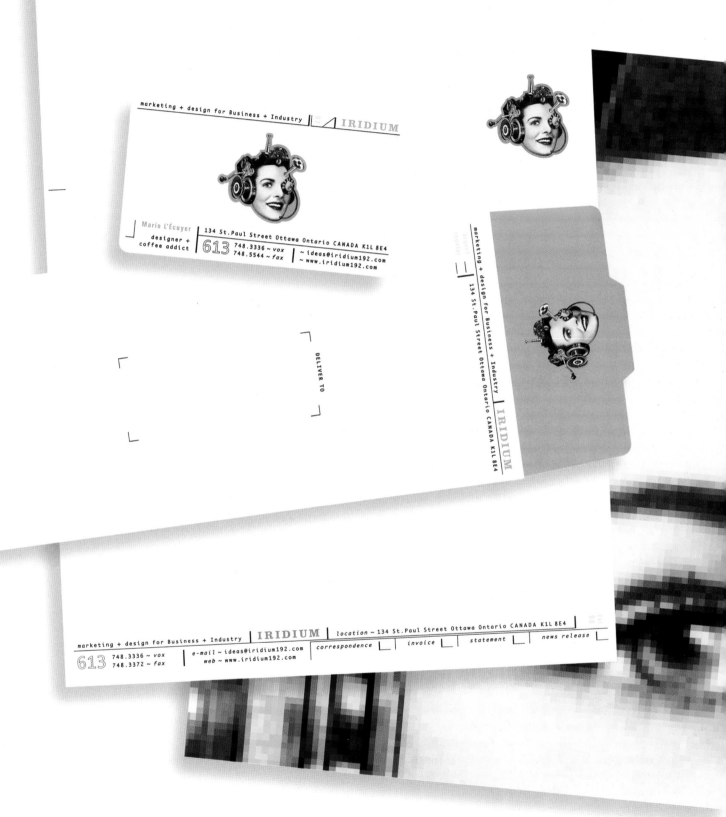

DELIVER TO

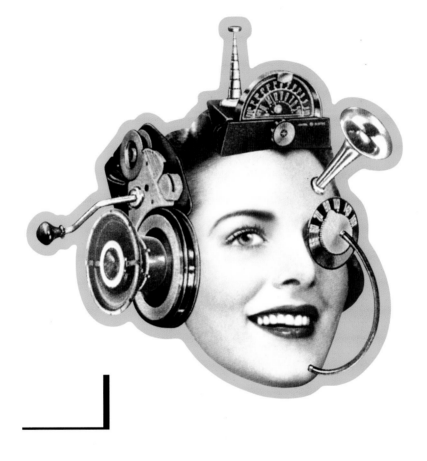

IRIDIUM

IRIDIUM, A DESIGN AGENCY | ART DIRECTORS MARIO L'ECUYER, JEAN-LUC DENAT | DESIGNER MARIO L'ECUYER | CLIENT IRIDIUM, A DESIGN AGENCY

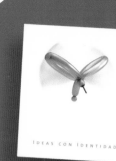

Juan Carlos Fernández Espinosa
Director Creativo

i d e o g r a m a

t: (777) 313 8466 ext. 101
f: (777) 317 6436
jc@ideograma.com
Tabasco 414-11, Las Maravillas
Cuernavaca, México 62230
www.ideograma.com

IDEAS CON IDENTIDAD

las Cuernavaca, México 62230 t: +52 (777) 313 8466 f: +52 (777) 317 6436 www.ideograma.com

en **ideas** claras y les damos forma a través
de mensajes flexibles y relevantes. Ideamos
identidades corporativas y posicionamientos
exitosos apoyados en un esfuerzo integral,
en lo que denominamos **identidad global.**

i d e o g r a m a

i d e o g r a m a
IDEAS CON IDENTIDAD

Cuernavaca, México 62230 t: +52 (777) 313 8466 f: +52 (777) 317 6436 www.ideograma.com

En **Ideograma** creamos nombres,
posicionamientos e identidades
corporativas exitosas.

Convertimos sólidas estrategias
de negocio en **ideas** claras y les
damos forma mediante mensajes
flexibles y relevantes. Ideamos
marcas memorables y eficaces
apoyados en un esfuerzo integral,
en lo que denominamos
identidad global.

IDEAS CON IDENTIDAD

IDEOGRAMA | ART DIRECTOR **JUAN CARLOS FERNÁNDEZ** | DESIGNER **SUSANNE ORTIZ** | CLIENT **IDEOGRAMA**

1

2

3 ALBUQUERQUE

4

FRUTAS ARTESANALES

1 **LISKA + ASSOCIATES** | ART DIRECTOR **STEVE LISKA** | DESIGNER **PAUL WONG** | CLIENT **SOTO DESIGNS**

2 **SAGMEISTER** | ART DIRECTOR **STEFAN SAGMEISTER** | DESIGNER **MATHIAS ERNSTBERGOR** | CLIENT **LOU REED**

3 **HAMBLY & WOOLLEY, INC.** | ART DIRECTOR **BOB HAMBLY** | DESIGNER **EMESE UNGAR** | CLIENT **LUIS ALBUQUERQUE**

4 **PUBLICIDAD GOMEZ CHICA** | ART DIRECTOR **SANTIAGO JARAMILLO** | CLIENT **TROPICO**

1

MULTIMEDIA

2

MICHAEL POWELL
Design & Art Direction

3

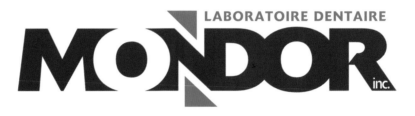

4

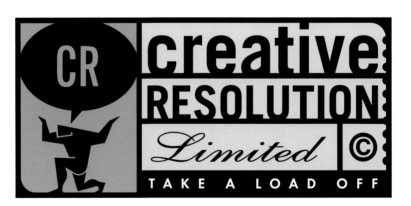

NO. 27 HOXTON STREET
LONDON N1 6NH
TELEPHONE + 44 (0) 20 7613 3886
FAX + 44 (0) 20 7729 8500
EMAIL name@pennyrich.co.uk
www.pennyrich.co.uk

VAT NO. 627 9237 14

PENNY RICH

PENNY RICH

NO. 27 HOXTON STREET
LONDON N1 6NH
TELEPHONE + 44 (0) 20 7613 3886
FAX + 44 (0) 20 7729 8500
EMAIL penny@pennyrich.co.uk
www.pennyrich.co.uk

D. DESIGN | ART DIRECTOR **DEREK SAMUEL** | CLIENT **PENNY RICH**

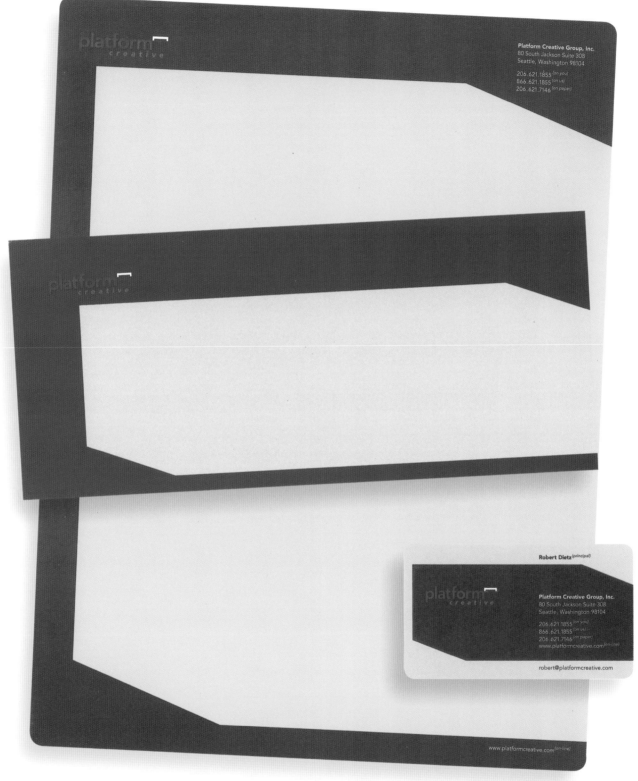

Platform Creative Group, Inc.
80 South Jackson Suite 308
Seattle, Washington 98104

206.621.1855 (on you)
866.621.1855 (on us)
206.621.7146 (on paper)

Robert Dietz (principal)

Platform Creative Group, Inc.
80 South Jackson Suite 308
Seattle, Washington 98104

206.621.1855 (on you)
866.621.1855 (on us)
206.621.7146 (on paper)
www.platformcreative.com (on-line)

robert@platformcreative.com

www.platformcreative.com (on-line)

PLATFORM CREATIVE GROUP | ART DIRECTOR **ROBERT DIETZ** | DESIGNERS **ROBERT DIETZ, TODD KGRAM** | CLIENTS **KATHY THOMPSON, JIM KOON**

digital design works, llc
1400 mill creek road
gladwyne, pa 19035

P 610.658.9900
F 610.658.9905

ddw
digital design works

interactive channels
broadband+web+new media

digital design works.com

c(p+p)²=roii | EXPERIENCE INTERACTIVE PERFORMANCE

digital design works.com

digital design works, llc
1400 mill creek road
gladwyne, pa 19035

P 610.658.9900 x 103
F 610.658.9905

ddw
digital design works

interactive channels
broadband+web+new media

Michael Bugler / senior designer
mbugler @ digital design works.com

digital design works, llc
1400 mill creek road
gladwyne, pa 19035

interactive channels
broadband+web+new media

ddw
digital design works

digital design works.com

EXPERIENCE INTERACTIVE PERFORMANCE

firebox *media*

firebox *media*
569 waller street
san francisco, ca
94117

569 waller street san francisco, ca 94117

firebox media

569 waller street san francisco, ca 94117 t: 415.436.9997 www.fireboxmedia.com

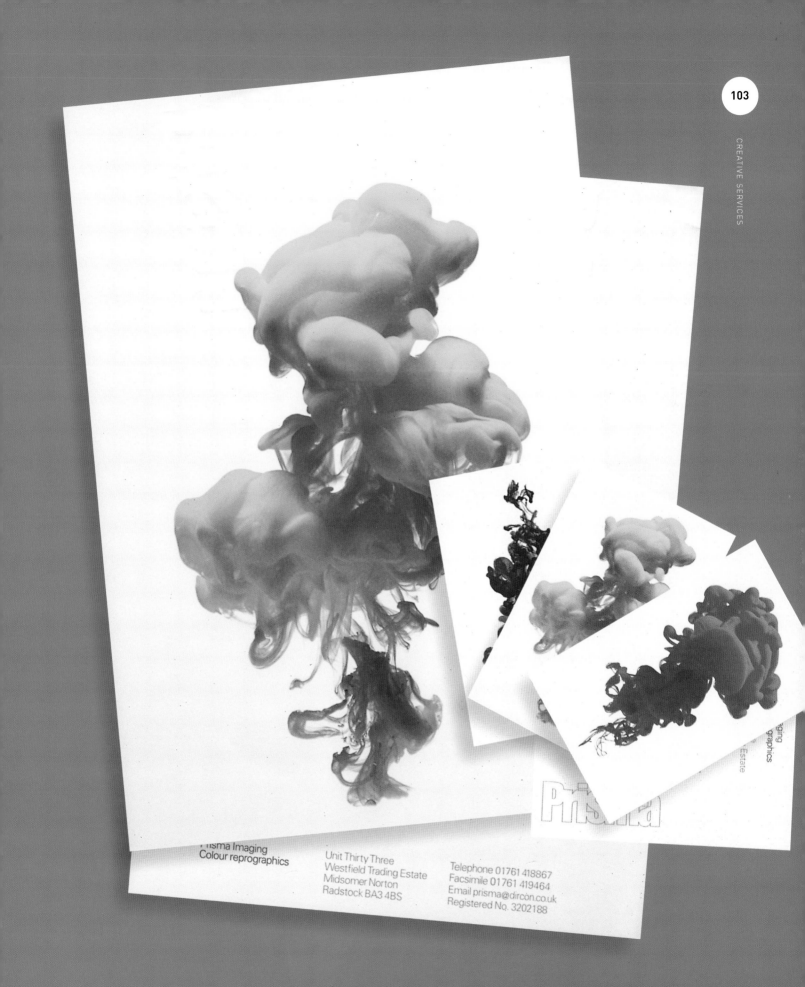

Prisma Imaging
Colour reprographics

Unit Thirty Three
Westfield Trading Estate
Midsomer Norton
Radstock BA3 4BS

Telephone 01761 418867
Facsimile 01761 419464
Email prisma@dircon.co.uk
Registered No. 3202188

NORTH BANK | ART DIRECTOR **SIMON CRYER** | CLIENT **PRISMA REPROGRAPHICS**

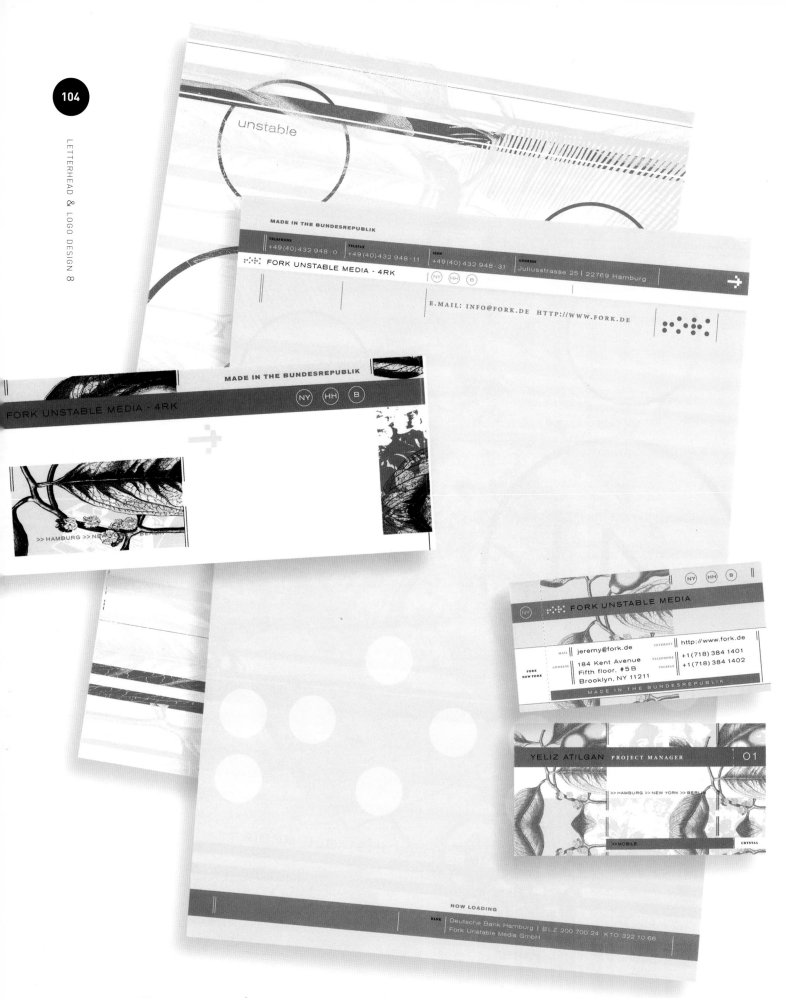

unstable

MADE IN THE BUNDESREPUBLIK

TELEPHONE	TELEFAX	ISDN	ADDRESS	
+49 (40) 432 948 · 0	+49 (40) 432 948 · 11	+49 (40) 432 948 · 31	Juliusstrasse 25	22769 Hamburg

FORK UNSTABLE MEDIA - 4RK (NY) (HH) (B)

E.MAIL: INFO@FORK.DE HTTP://WWW.FORK.DE

MADE IN THE BUNDESREPUBLIK

(NY) (HH) (B)

FORK UNSTABLE MEDIA - 4RK

>> HAMBURG >> NEW BERL

FORK UNSTABLE MEDIA

(NY) (HH) (B)

MAIL	jeremy@fork.de	INTERNET	http://www.fork.de
ADDRESS	184 Kent Avenue Fifth floor, #5B Brooklyn, NY 11211	TELEPHONE	+1 (718) 384 1401
		TELEFAX	+1 (718) 384 1402

FORK NEW YORK

MADE IN THE BUNDESREPUBLIK

YELIZ ATILGAN PROJECT MANAGER O1

>> HAMBURG >> NEW YORK >> BERLIN

>> MOBILE CRYSTAL

NOW LOADING

BANK Deutsche Bank Hamburg | BLZ 200 700 24 KTO 322 10 66
Fork Unstable Media GmbH

MARIUS FAHRNER DESIGN | ART DIRECTOR MARIUS FAHRNER | CLIENT FORLI UNSTABLE MEDIA

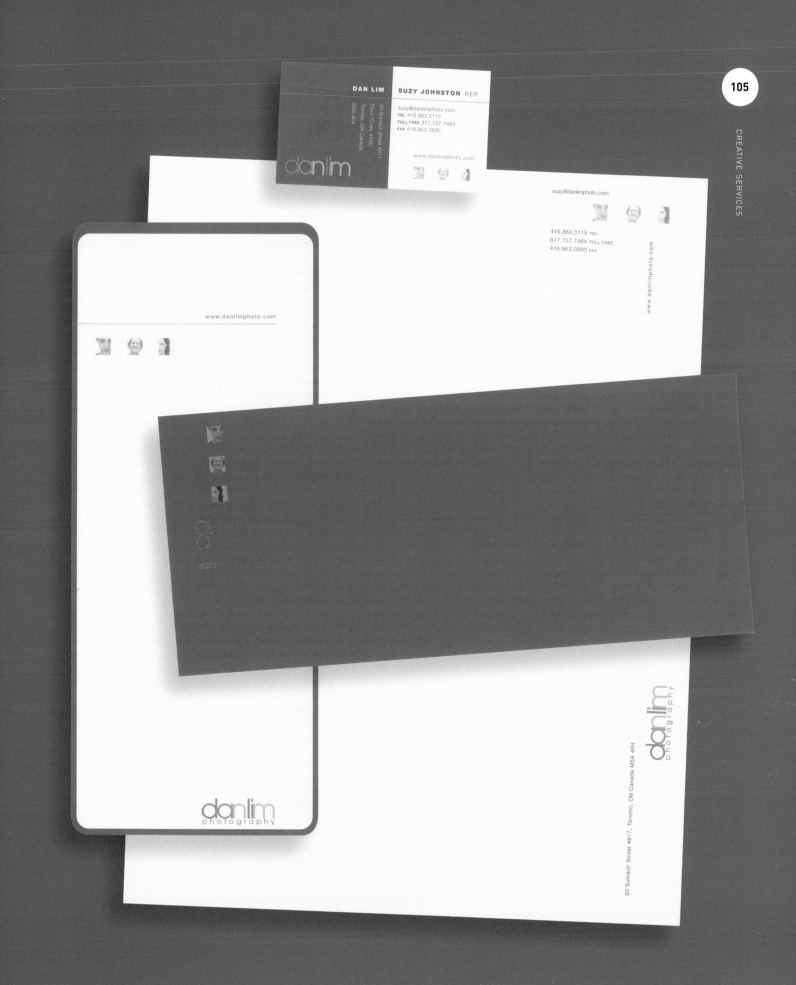

DAN LIM | **SUZY JOHNSTON** REP

suzy@danlimphoto.com
TEL 416.863.5115
TOLL FREE 877.737.7464
FAX 416.863.0890

www.danlimphoto.com

90 Sumach Street #617
Door Code #600
Toronto, ON Canada
M5A 4R4

suzy@danlimphoto.com

416.863.5115 TEL
877.737.7464 TOLL FREE
416.863.0890 FAX

www.danlimphoto.com

www.danlimphoto.com

90 Sumach Street #617, Toronto, ON Canada M5A 4R4

THE RIORDON DESIGN GROUP | ART DIRECTOR **DAN WHEATON** | DESIGNER **TIM WARKNOCK** | CLIENT **DAN LIM PHOTOGRAPHY**

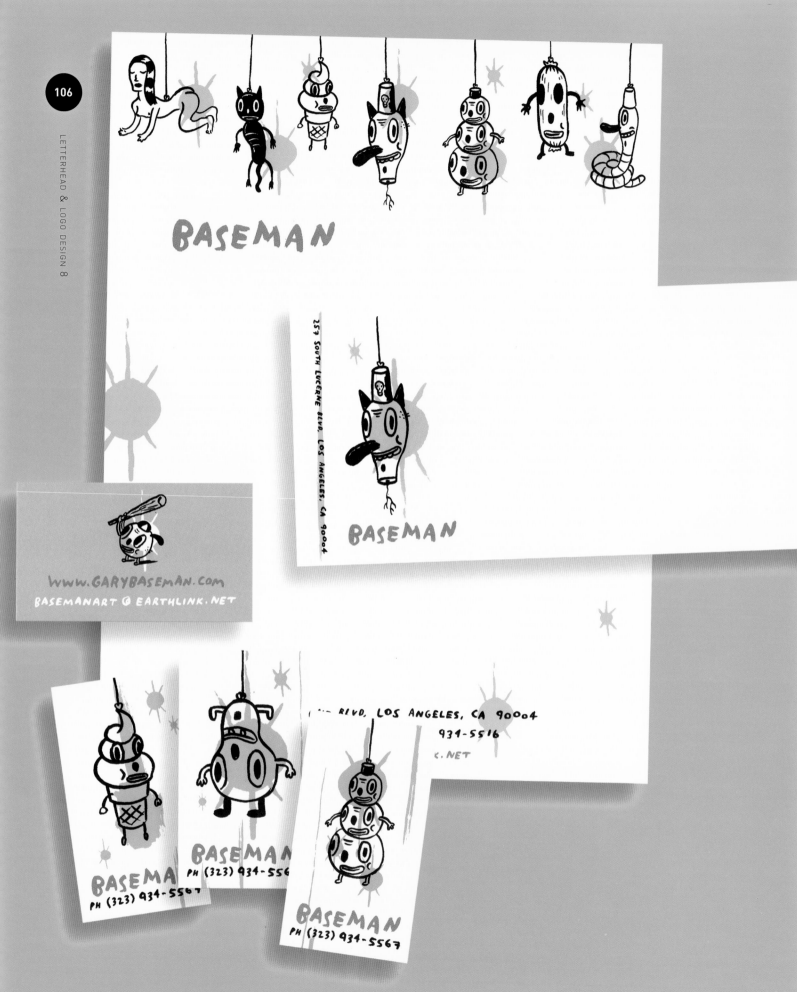

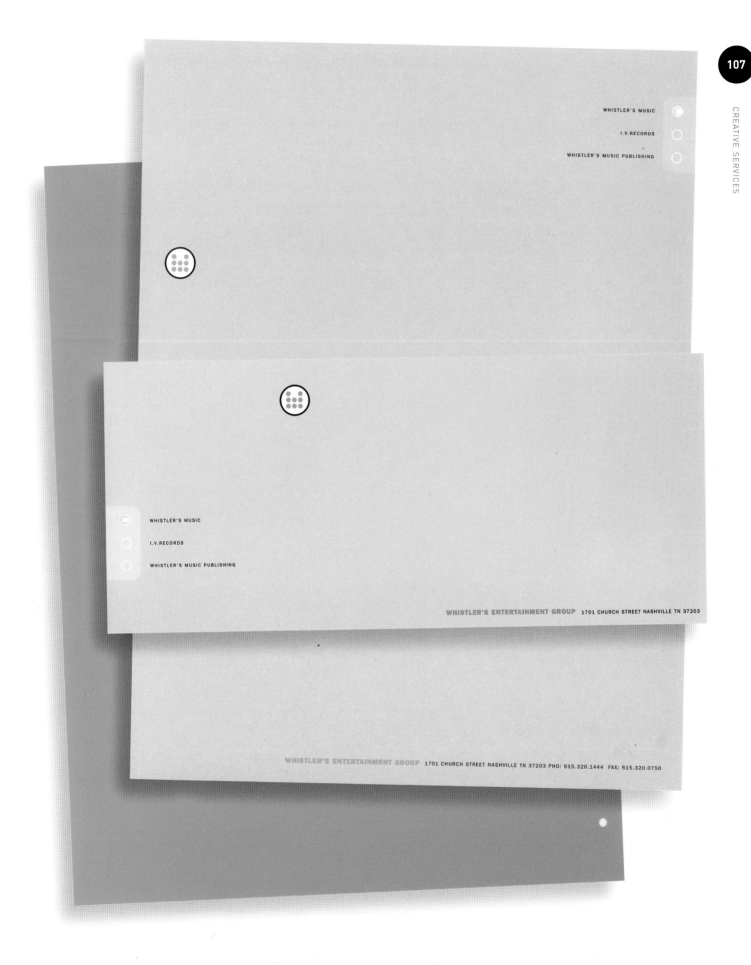

WHISTLER'S MUSIC

I.V.RECORDS

WHISTLER'S MUSIC PUBLISHING

WHISTLER'S MUSIC

I.V.RECORDS

WHISTLER'S MUSIC PUBLISHING

WHISTLER'S ENTERTAINMENT GROUP 1701 CHURCH STREET NASHVILLE TN 37203

WHISTLER'S ENTERTAINMENT GROUP 1701 CHURCH STREET NASHVILLE TN 37203 PHO: 615.320.1444 FAX: 615.320.0750

LEWIS COMMUNICATIONS | ART DIRECTOR ROBERT FROEDGE | CLIENT WHISTLER'S ENTERTAINMENT GROUP

CLAUDIO VASQUEZ

[7 Morningside Ave, Upper Montclair, NJ 07043]

TEL 917.750.5216

[Carson Vasquez Photography]

[Carson Vasquez Photography] 7 Morningside Ave, Upper Montclair, NJ 07043

TOM & JOHN: ADC | ART DIRECTORS TOM SIEU, JOHN GIVENS | CLIENT CARSON VASQUEZ

kevduttonphotography

57 Dorchester Court
London
SE24 9QY

T/F 020 7274 3337
M 07973 113969
E kevdutton@aol.com

VAT reg 681 5010 56

www.lepalmier.de

Le_Palmier

Andreas Palm Design

Le_Palmier
Andreas Palm Design
Große Brunnenstraße 63a

22763 Hamburg

www.lepalmier.de

Fon_040.460 690-61 : Fax_040.460 690-62
Große Brunnenstraße 63a : 22763 Hamburg
eMail_design@lepalmier.de

Andreas Palm Design

Le_Palmier

Fon_040.460 690-61 : Fax_040.460 690-62
Große Brunnenstraße 63a : D_22763 Hamburg
eMail_design@lepalmier.de

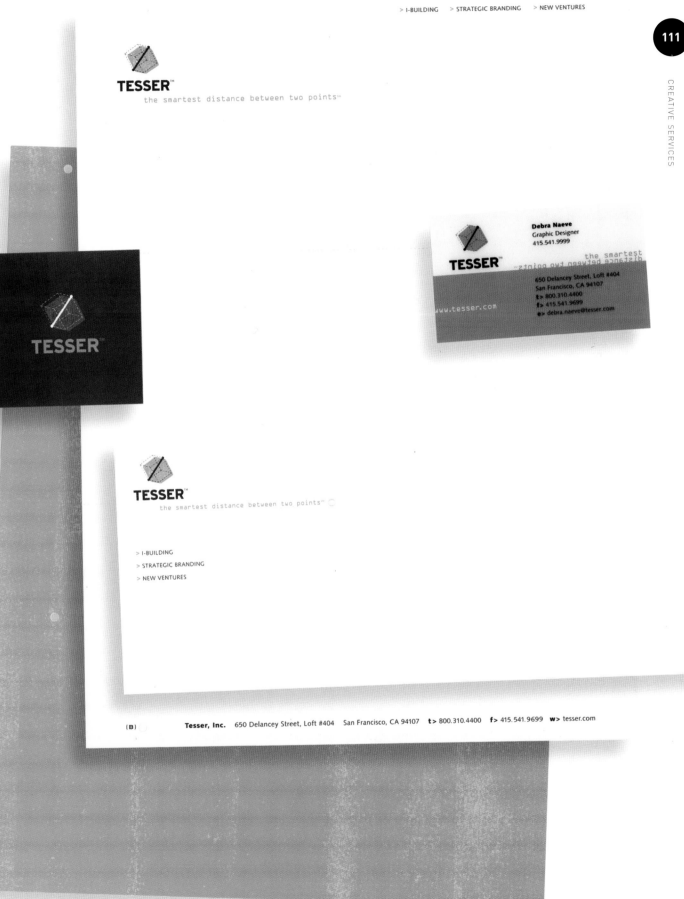

TESSER™
the smartest distance between two points™

TESSER™

Debra Naeve
Graphic Designer
415.541.9999

the smartest
distance between two points™

650 Delancey Street, Loft #404
San Francisco, CA 94107
t> 800.310.4400
f> 415.541.9699
e> debra.naeve@tesser.com
www.tesser.com

TESSER™
the smartest distance between two points™

> I-BUILDING
> STRATEGIC BRANDING
> NEW VENTURES

(B) **Tesser, Inc.** 650 Delancey Street, Loft #404 San Francisco, CA 94107 **t>** 800.310.4400 **f>** 415.541.9699 **w>** tesser.com

TESSER, INC. | ART DIRECTOR TRE MUSCO | DESIGNERS KIMBERLY CROSS, SANDRINE ALBOUY | CLIENT TESSER, INC.

ratio one.

SIR JOHN LYON HOUSE
5 HIGH TIMBER STREET
BLACKFRIARS
LONDON
EC4V 3NX

TEL 020 7557 4760
FAX 020 7557 4768

WWW.RATIOONE.COM

ratio one.

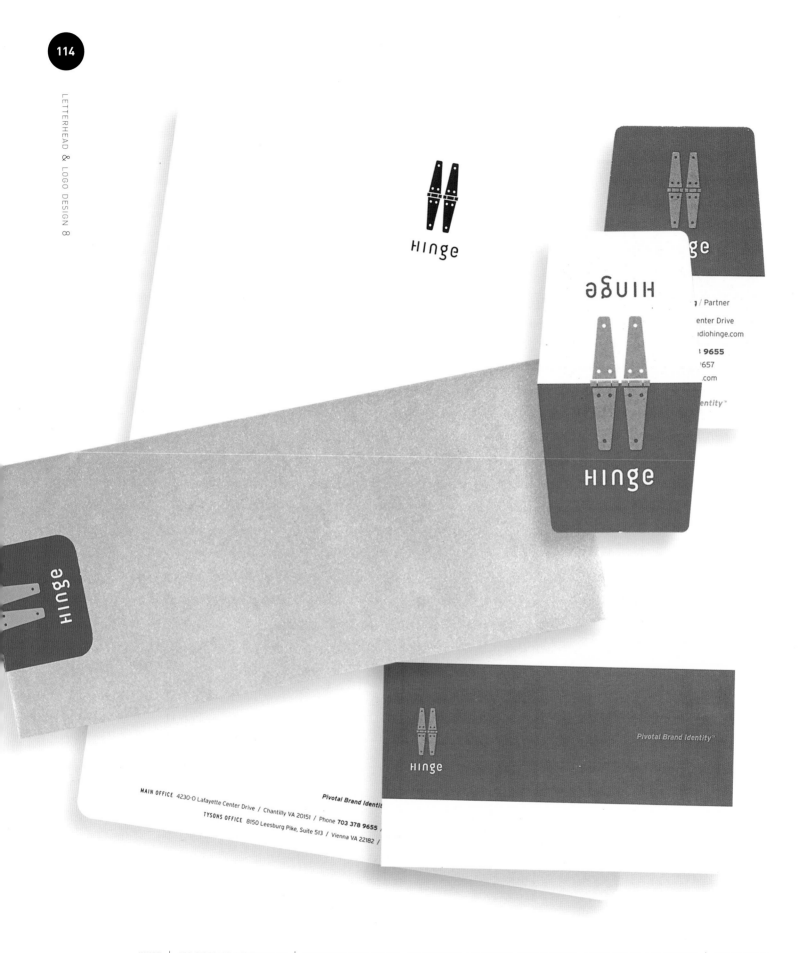

HINGE | ART DIRECTOR **DOUG FULLER** | DESIGNERS **DOUG FULLER, JEN STERLING, LIZ WEAVER, GREG SPRAKER, AARON TAYLOR, KIM GUARINO** | CLIENT **HINGE**

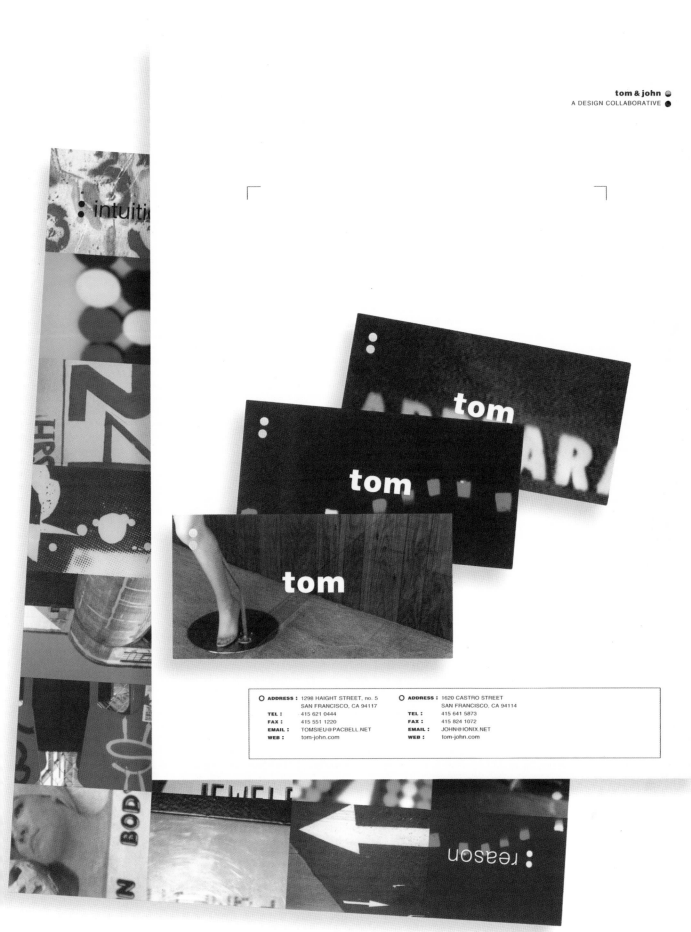

tom & john
A DESIGN COLLABORATIVE

○ **ADDRESS :** 1298 HAIGHT STREET, no. 5
SAN FRANCISCO, CA 94117
TEL : · 415 621 0444
FAX : 415 551 1220
EMAIL : TOMSIEU@PACBELL.NET
WEB : tom-john.com

○ **ADDRESS :** 1620 CASTRO STREET
SAN FRANCISCO, CA 94114
TEL : 415 641 5873
FAX : 415 824 1072
EMAIL : JOHN@IONIX.NET
WEB : tom-john.com

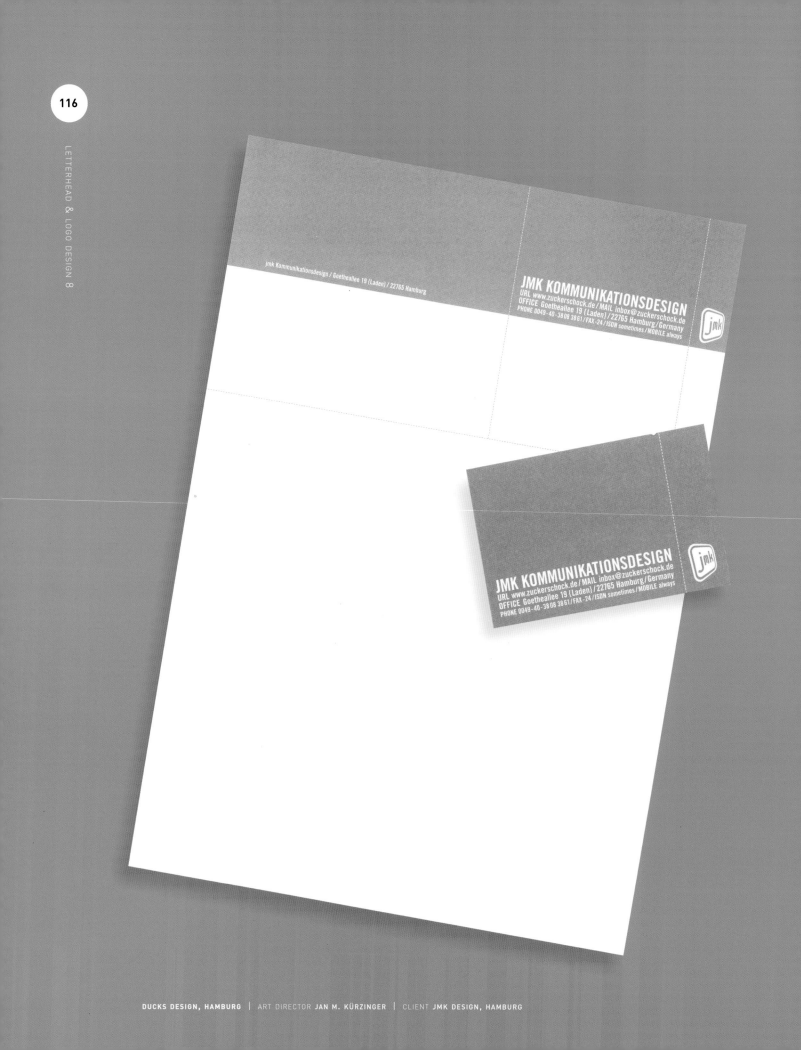

jmk Kommunikationsdesign / Goetheallee 19 (Laden) / 22765 Hamburg

JMK KOMMUNIKATIONSDESIGN
URL www.zuckerschock.de / MAIL inbox@zuckerschock.de
OFFICE Goetheallee 19 (Laden) / 22765 Hamburg / Germany
PHONE 0049-40-38 08 38 61 / FAX-24 / ISDN sometimes / MOBILE always

JMK KOMMUNIKATIONSDESIGN
URL www.zuckerschock.de / MAIL inbox@zuckerschock.de
OFFICE Goetheallee 19 (Laden) / 22765 Hamburg / Germany
PHONE 0049-40-38 08 38 61 / FAX-24 / ISDN sometimes / MOBILE always

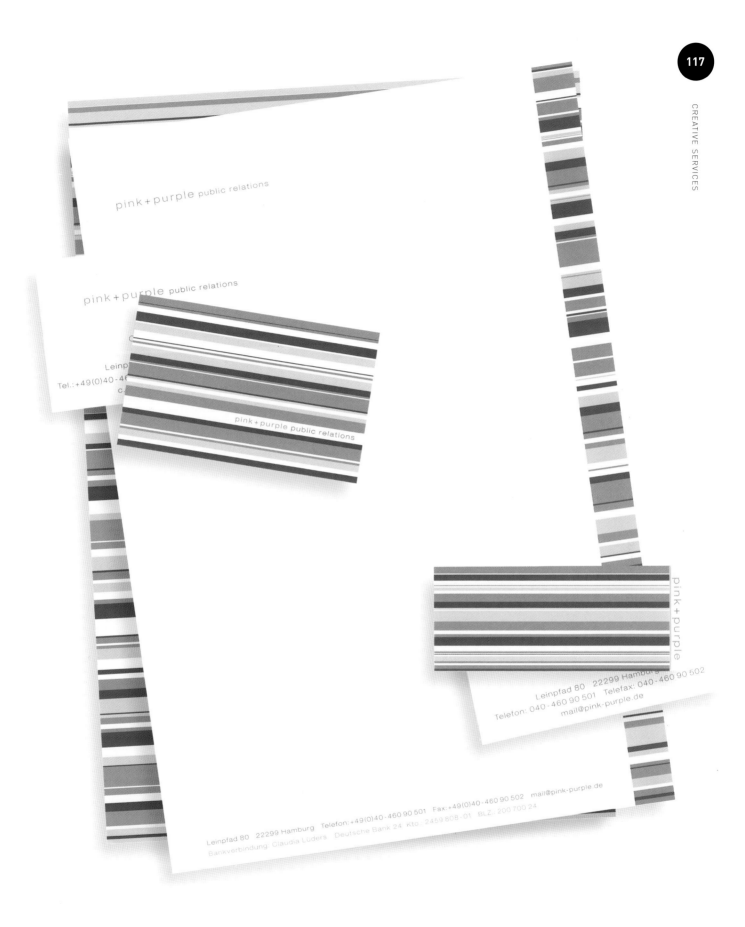

pink+purple public relations

pink+purple public relations

pink+purple public relations

pink+purple

Leinpfad 80 22299 Hamburg
Telefon: 040-460 90 501 Telefax: 040-460 90 502
mail@pink-purple.de

Leinpfad 80 22299 Hamburg Telefon:+49(0)40-460 90 501 Fax:+49(0)40-460 90 502 mail@pink-purple.de
Bankverbindung: Claudia Lüders Deutsche Bank 24 Kto.: 2459 808-01 BLZ: 200 700 24

RETAIL, RESTAURANT, AND HOSPITALITY

1

2

3

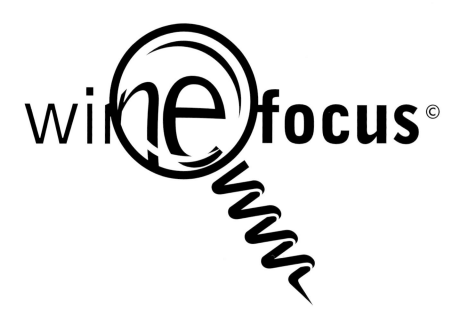

1 MORTENSEN DESIGN | ART DIRECTOR GORDON MORTENSEN | DESIGNER MARIANA B. PABON | CLIENT NEW GROUND

2 LLOYD'S GRAPHIC DESIGN & COMMUNICATION | DESIGNER ALEXANDER LLOYD | CLIENT X'FOLIATE

3 LLOYD'S GRAPHIC DESIGN & COMMUNICATION | DESIGNER ALEXANDER LLOYD | CLIENT WINE FOCUS

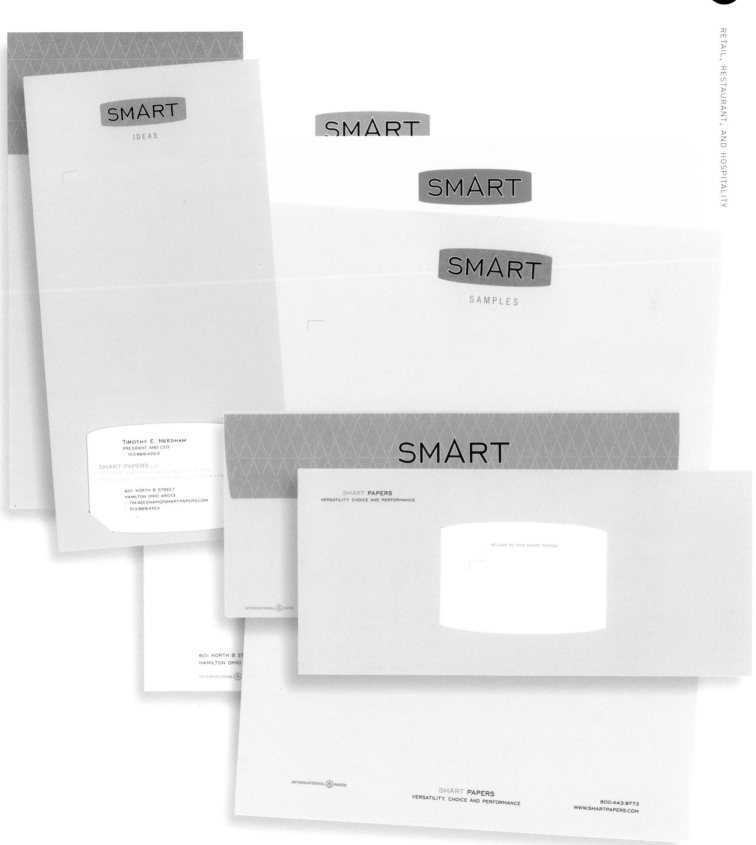

1

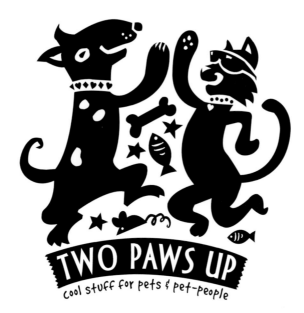

2 3

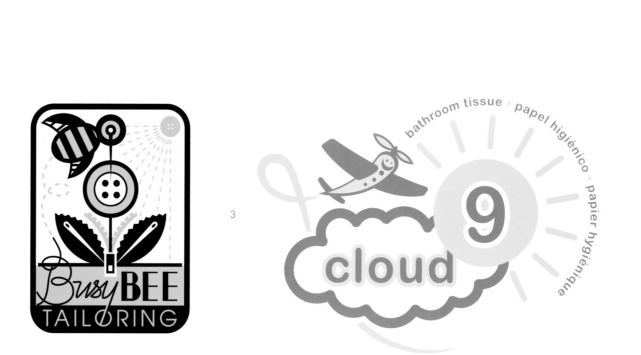

1 **HONEY DESIGN** | ART DIRECTOR **ROBIN HONEY** | CLIENT **TWO PAWS UP**

2 **SAYLES GRAPHIC DESIGN** | DESIGNER **JOHN SAYLES** | CLIENT **BUSY BEE TAILORING**

3 **SAYLES GRAPHIC DESIGN** | ART DIRECTOR **JOHN SAYLES** | CLIENT **CLOUD 9**

1

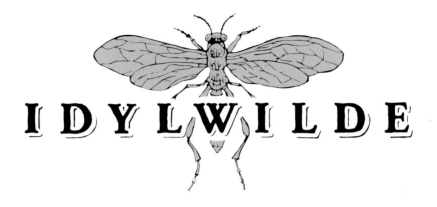

2

1 PURE DESIGN INC. | ART DIRECTOR RACHELLE FISHER | DESIGNER JOHN FISHER | CLIENT IDYLWILDE FLIES
2 GILLESPIE DESIGN INC. | ART DIRECTOR MAUREEN GILLESPIE | DESIGNER LIZ SCHENKEL | CLIENT WENDY AND AMY (BABY STATIONERY)

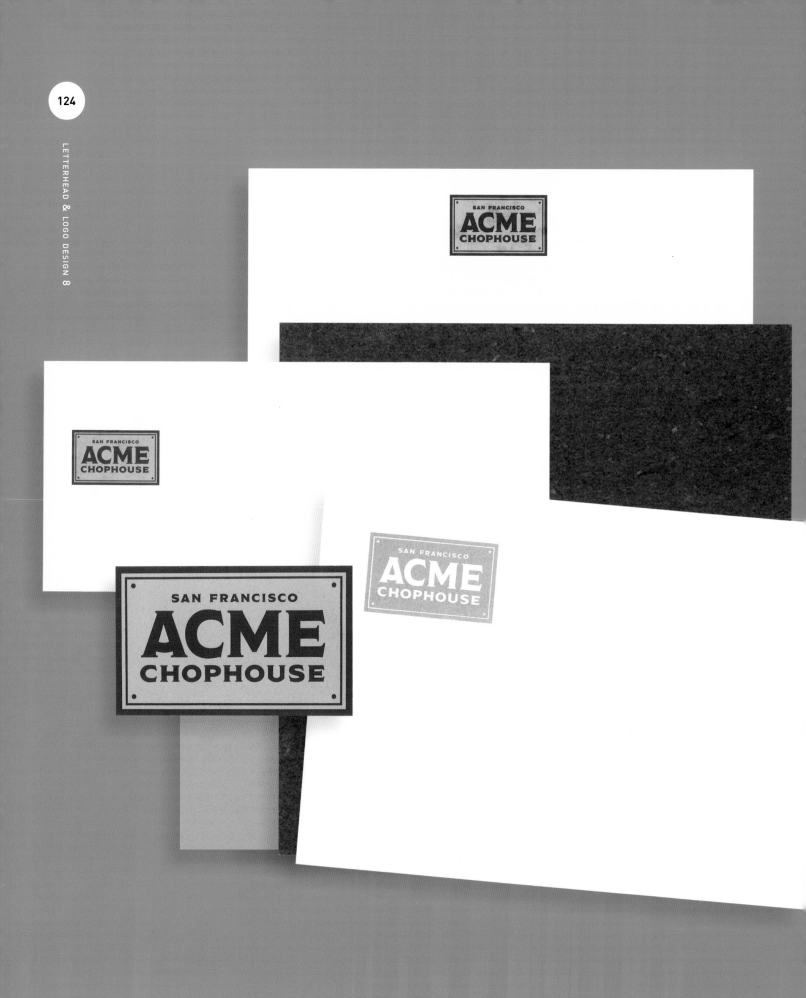

ENERGY ENERGY DESIGN | ART DIRECTOR LESLIE GUIDICE | DESIGNERS STACY GUIDICE, JEANETTE ARAMBURU | CLIENT ACME CHOPHOUSE

1
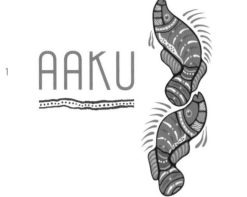

2
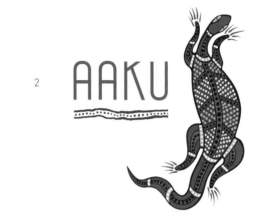

3
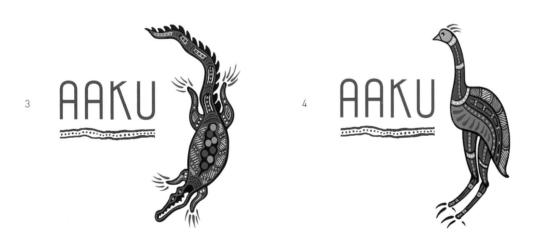

4

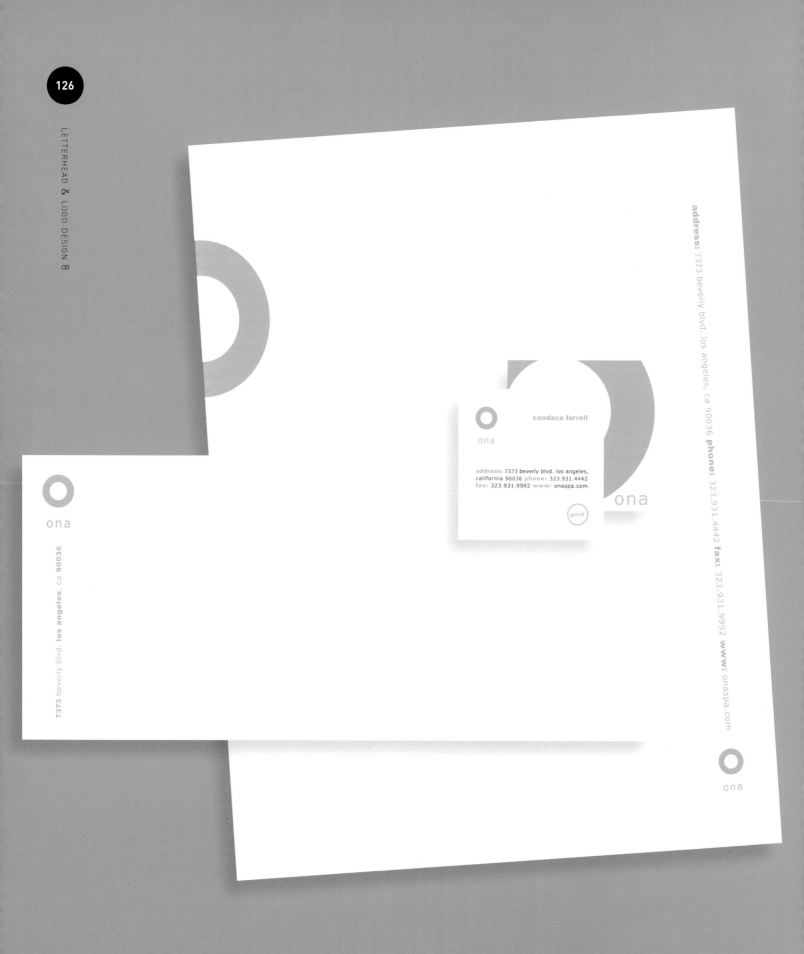

1

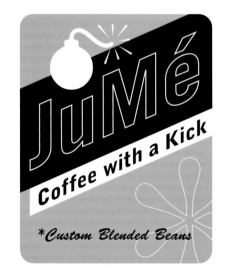

2

3

4

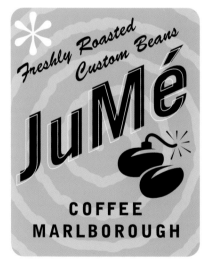

1–4 **LLOYD'S GRAPHIC DESIGN & COMMUNICATION** | DESIGNER ALEXANDER LLOYD | CLIENT JUT BISHOP, MEA IVRY

ORIGINAL CASUAL APPAREL FOR FENCERS

Recipient

BiG
For Our
BRITCHES ™

Distribution Location
30 THE FENWAY **BOSTON, MASSACHUSETTS 02215**

Contact
617.515.0955

Digital Location
www.big4ourbritches.com

BIG FOR OUR BRITCHES

Since 2001

S
M
L
XL

1

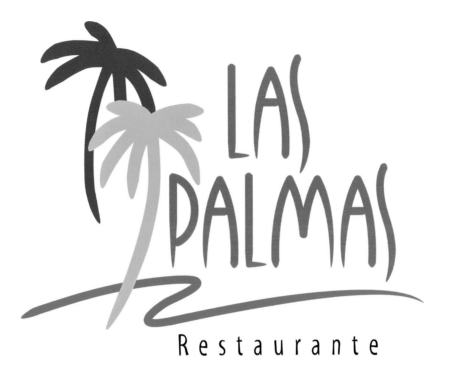

2

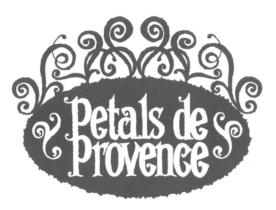

3

1 **PUBLICIDAD GÓMEZ CHICA** | DESIGNER **SANTIAGO JARAMILLO** | CLIENT **LAS PALMAS RESTAURANT**
2 **SAYLES GRAPHIC DESIGN** | ART DIRECTOR **JOHN SAYLES** | CLIENT **PETALS DE PROVENCE**
3 **SAYLES GRAPHIC DESIGN** | DESIGNER **JOHN SAYLES** | CLIENT **NEPTUNE'S SEAGRILL**

1

2

1 BE.DESIGN | ART DIRECTOR WILL BURKE | DESIGNERS ERIC READ, YUSUKE ASAKA, CORALIE RUSSO CLIENT WORLDWISE, INC.
2 RE: SALZMAN DESIGNS | ART DIRECTOR IDA CHEINMAN | DESIGNERS IDA CHEINMAN, RICK SALZMAN | CLIENT LEE'S ICE CREAM

FRONTIER ROOM

FRONTIER ROOM

2203 First Avenue Seattle Washington 98121
p 206/ 956-RIBS (7427)
Paul Michael, head chef e frontierroom@seanet.com

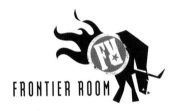

FRONTIER ROOM

2203 First Avenue Seattle Washington 98121 p 206/ 956-RIBS (7427) e frontierroom@seanet.com

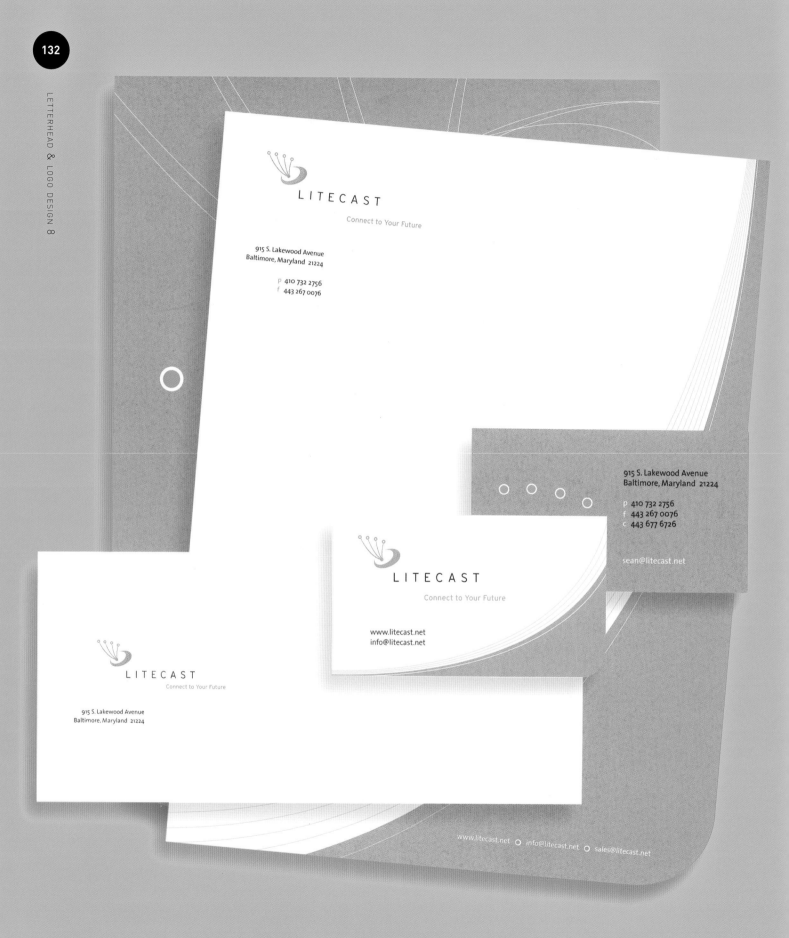

LITECAST

Connect to Your Future

915 S. Lakewood Avenue
Baltimore, Maryland 21224

p 410 732 2756
f 443 267 0076

915 S. Lakewood Avenue
Baltimore, Maryland 21224

p 410 732 2756
f 443 267 0076
c 443 677 6726

sean@litecast.net

LITECAST

Connect to Your Future

www.litecast.net
info@litecast.net

LITECAST

Connect to Your Future

915 S. Lakewood Avenue
Baltimore, Maryland 21224

www.litecast.net info@litecast.net sales@litecast.net

RE: SALZMAN DESIGNS | ART DIRECTOR **IDA CHEINMAN** | DESIGNERS **IDA CHEINMAN, RICK SALZMAN** | CLIENT **LITECAST**

LITECAST

RE: SALZMAN DESIGNS | ART DIRECTOR **IDA CHEINMAN** | DESIGNERS **IDA CHEINMAN, RICK SALZMAN** | CLIENT **LITECAST**

1

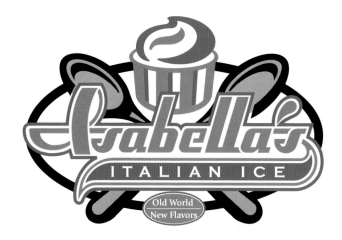

2

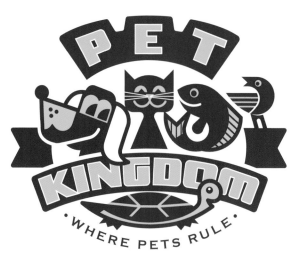

1 **SAYLES GRAPHIC DESIGN** | ART DIRECTOR **JOHN SAYLES** | CLIENT **ISABELLA'S**
2 **SAYLES GRAPHIC DESIGN** | ART DIRECTOR **JOHN SAYLES** | CLIENT **PET KINGDOM**

1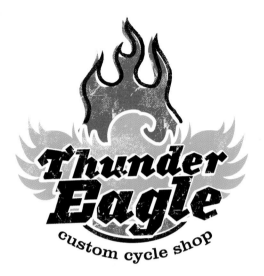

2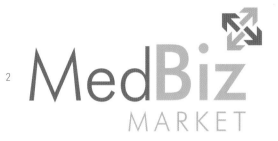

3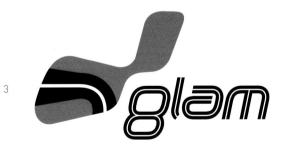

4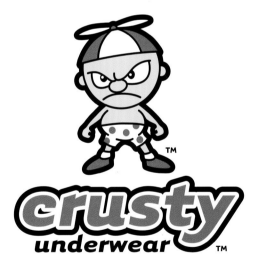

1 **HG DESIGN** | DESIGNER **MATT PIERCE** | CLIENT **THUNDER EAGLE CYCLE SHOP**

2 **CFX CREATIVE** | ART DIRECTOR **CARLY H. FRANKLIN** | CLIENT **MEDBIZMARKET**

3 **GASKET** | ART DIRECTOR **MIKE CHRISTOFFEL** | CLIENT **GLAM**

4 **RICK JOHNSON & COMPANY** | DESIGNER **TIM MCGRATH** | CLIENT **CRUSTY UNDERWEAR**

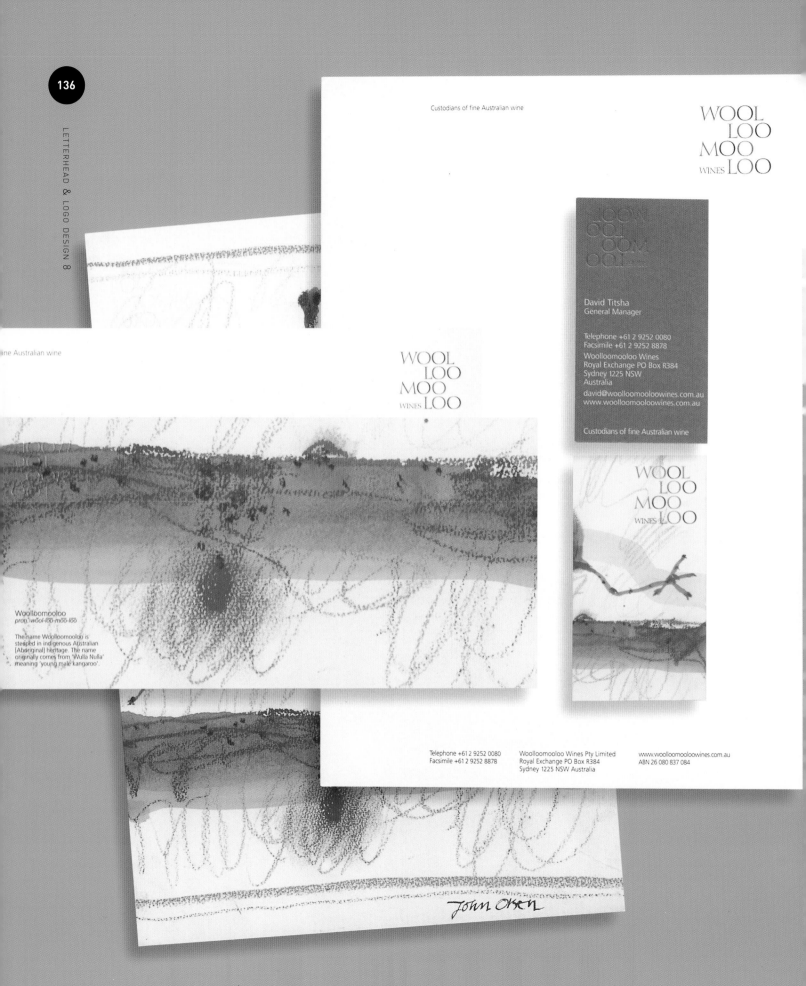

Custodians of fine Australian wine

WOOL
LOO
MOO
WINES LOO

David Titsha
General Manager

Telephone +61 2 9252 0080
Facsimile +61 2 9252 8878

Woolloomooloo Wines
Royal Exchange PO Box R384
Sydney 1225 NSW
Australia

david@woolloomooloowines.com.au
www.woolloomooloowines.com.au

Custodians of fine Australian wine

fine Australian wine

WOOL
LOO
MOO
WINES LOO

WOOL
LOO
MOO
WINES LOO

Woolloomooloo
pron. wŏŏl-lŏŏ-mŏŏ-lŏŏ

The name Woolloomooloo is
steeped in indigenous Australian
[Aboriginal] heritage. The name
originally comes from 'Wulla Nulla'
meaning 'young male kangaroo'.

Telephone +61 2 9252 0080
Facsimile +61 2 9252 8878

Woolloomooloo Wines Pty Limited
Royal Exchange PO Box R384
Sydney 1225 NSW Australia

www.woolloomooloowines.com.au
ABN 26 080 837 084

John Olsen

EMERY VINCENT DESIGN | ART DIRECTOR EMERY VINCENT DESIGN | CLIENT WOOLLOOMOOLOO WINES

1

EQUIFEMME
LIPOSOMAL PROGESTERONE CREAM

2

PURE ASIAN CUISINE

1 CFX CREATIVE | ART DIRECTOR CARLY H. FRANKLIN | CLIENT WHEATLAND NATURALS
2 INOX DESIGN | DESIGNER ALESSANDRO FLORIDIA | CLIENT MR. GAO

1

grounded
damn good coffee

2

3

1 **ZIGZAG DESIGN** | ART DIRECTOR **RACHEL KARACA** | CLIENT **GROUNDED**

2 **MIAMI AD SCHOOL** | ART DIRECTOR **JONATHAN GOUTHIER** | DESIGNER **MIMI AWAMURA** | CLIENT **DOGMA GRILL**

3 **VRONTIKIS DESIGN OFFICE** | ART DIRECTOR **PETRULA VRONTIKIS** | DESIGNER **RON BLAYLOCK** | CLIENT **RED CAR WINE CO.**

1

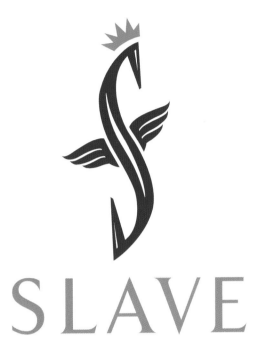

2

1 BE.DESIGN | ART DIRECTOR ERIC READ | DESIGNER DEBORAH SMITH READ | CLIENT SLAVE
2 BE.DESIGN | ART DIRECTOR ERIC READ | DESIGNERS ERIC READ, CORALIE RUSSO | CLIENT COST PLUS WORLD MARKET

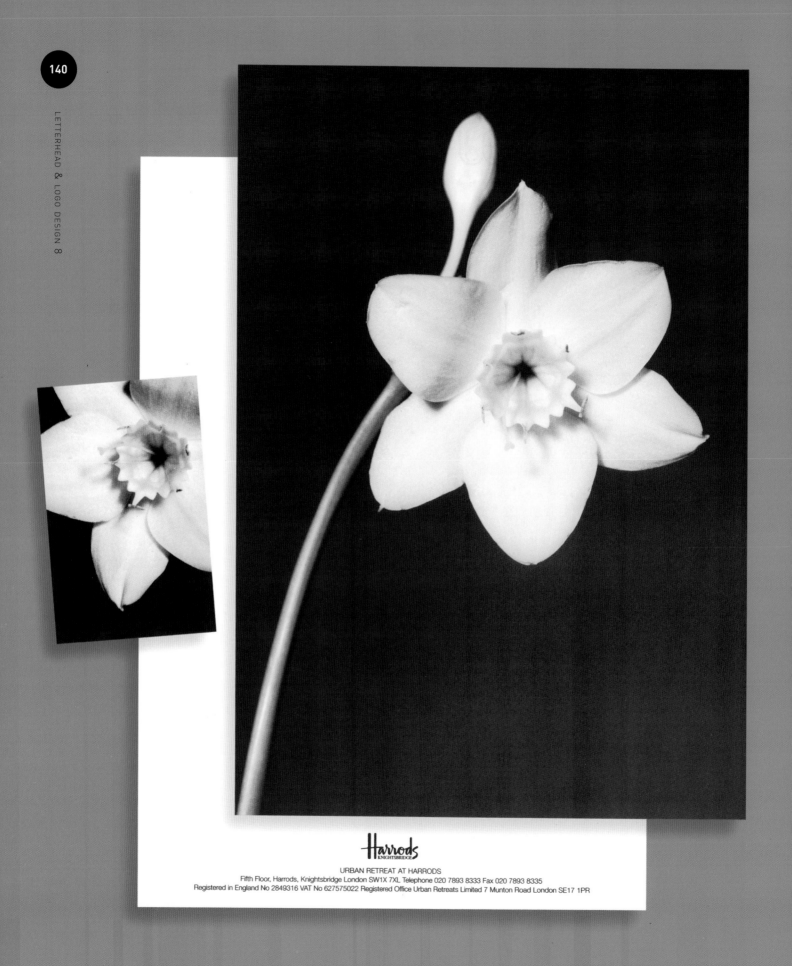

Harrods
KNIGHTSBRIDGE

URBAN RETREAT AT HARRODS
Fifth Floor, Harrods, Knightsbridge London SW1X 7XL Telephone 020 7893 8333 Fax 020 7893 8335
Registered in England No 2849316 VAT No 627575022 Registered Office Urban Retreats Limited 7 Munton Road London SE17 1PR

D. DESIGN | ART DIRECTOR **DEREK SAMUEL** | CLIENT **GEORGE HAMMER**

1

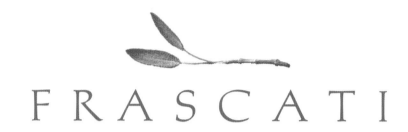

2

3

SCAPPUCCI

1 BAKKEN CREATIVE CO. | ART DIRECTOR MICHELLE BAKKEN | CLIENT FRASCATI RESTAURANT
2 BE.DESIGN | ART DIRECTOR WILL BURKE | DESIGNERS ERIC READ, DIANE HILDE | CLIENT COST PLUS WORLD MARKET
3 METZLER ASSOCIATES | ART DIRECTOR MARC-ANTOINE HERRMANN | DESIGNER JEAN-RENEE GUEGAN | CLIENT SCAPPUCCI

dish
CATERING

dish
CATERING

2433 BOONE AVE VENICE CA 90291

tel 310 600 0144 fax 310 827 7367

www.dishcatering.com

dish
CATERING

2433 BOONE AVE VENICE CA 90291

tel 310 600 0144 fax 310 827 7367

www.dishcatering.com

SPECIAL MODERN DESIGN | ART DIRECTOR **KARN BARRANCO** | CLIENT **DISH CATERING**

1

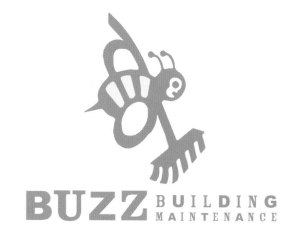

2

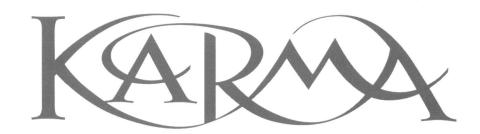

3

Sukita®

1 **INSIGHT DESIGN COMMUNICATIONS** | ART DIRECTOR **TRACY HOLDMAN** | DESIGNER **LEAH CARMICHAEL** | CLIENT **BUZZ BUILDING MAINTENANCE**

2 **BE.DESIGN** | ART DIRECTOR **ERIC READ** | DESIGNER **DEBORAH SMITH READ** | CLIENT **KARMA CREATIONS**

3 **DIL BRANDS** | ART DIRECTOR **NORIVAL MARTINS** | CLIENT **AMBEV**

URBAN RETREATS LTD 7 Munton Road London SE17 IPR Telephone +44(0)20 7410 1651 Fax +44(0)20 7410 1650

URBAN RETREATS LIMITED Telephone 0777 964 8478 Fax 020 7410 1650

URBAN
RETREATS

TANIA BARD

7 Munton Road London SE17 IPR

1

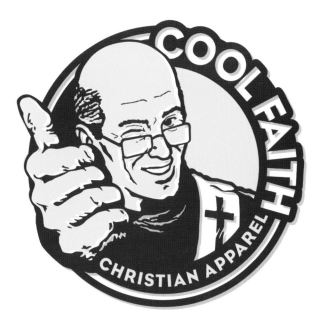

2

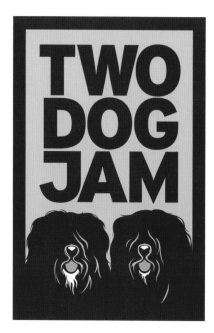

1 **KNEZIC/PAVONE** | ART DIRECTOR ROBINSON C. SMITH | CLIENT COOL FAITH APPAREL
2 **KNEZIC/PAVONE** | ART DIRECTOR ROBINSON C. SMITH | CLIENT STONE COTTAGE PRESERVES

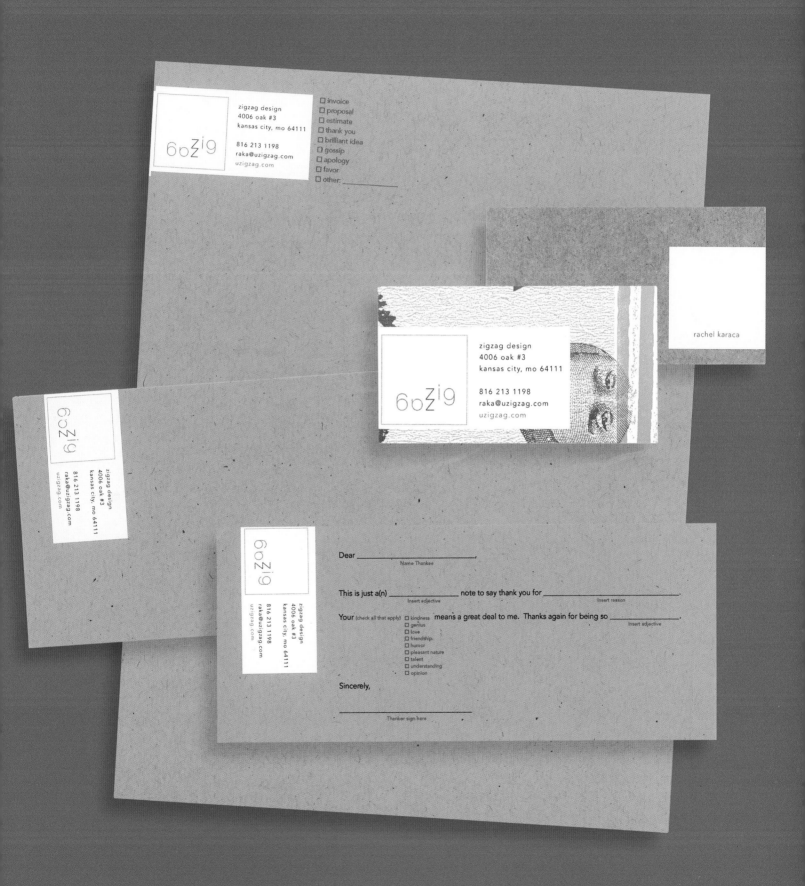

taktil.

taktil.

Dirk Wallstein
Geschäftsführung

Gesellschaft für
Kommunikation bR mbH

Hedwigstr. 24
D-44809 Bochum
Fon +49 (0) 2 34 · 95 71 94-13
Fax +49 (0) 2 34 · 95 71 94-99
mobil +49 (0) 1 63 · 3 10 47 13
email wallstein@taktil.de
Internet www.taktil.de

OHANA FARM

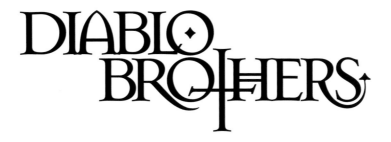

1 **BE.DESIGN** | ART DIRECTOR **ERIC READ** | DESIGNERS **ERIC READ, ANGELA HILDEBRAND** | CLIENT **OHANA FARM**
2 **KNEZIC/POVONE** | ART DIRECTOR **ROBINSON C. SMITH** | CLIENT **DIABLO BROS. WINERY**

1

3

1 **LOVE COMMUNICATIONS** | ART DIRECTOR **PRESTON WOOD** | CLIENT **CRAIG LEE**
2 **I. PARIS DESIGN** | ART DIRECTOR **ISAAC PARIS** | CLIENT **EUROPE ON THE CORNER JEWELRY SHOP**

1

metamorphosis
MIND + BODY BOUTIQUE

2

GRAHAM HILL
APARTMENTS

3

PASEO COLORADO
PASADENA

4

1 **AIR DESIGN** | ART DIRECTOR NOAH SCALIN | CLIENT **METAMORPHOSIS**

2 **KNEZIC/PAVONE** | ART DIRECTOR ROBINSON C. SMITH | CLIENT **GRAHAM HILL APARTMENTS**

3 **SMULLEN DESIGN** | ART DIRECTORS MAUREEN SMULLEN, RUBEN ESPARZA | DESIGNER RUBEN ESPARZA | CLIENT **TRIZEC HAHN DEVELOPMENT**

4 **ENTERPRISE IG** | ART DIRECTOR HIDETAKA MATSUNAGA | DESIGNER RINA TANAKA | CLIENT **FOUR SEASONS HOTEL TOKYO AT MARUNOUCHI**

1

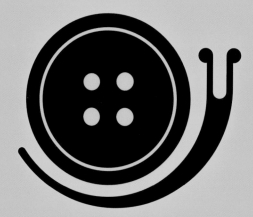

2

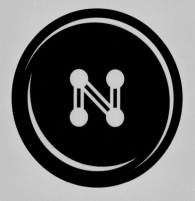

1 **ROBERT FROEDGE DESIGN** | ART DIRECTOR **ROBERT FROEDGE** | CLIENT **SNIPS & SNAILS**
2 **ROBERT FROEDGE DESIGN** | ART DIRECTOR **ROBERT FROEDGE** | CLIENT **NELLIE'S ORIGINALS**

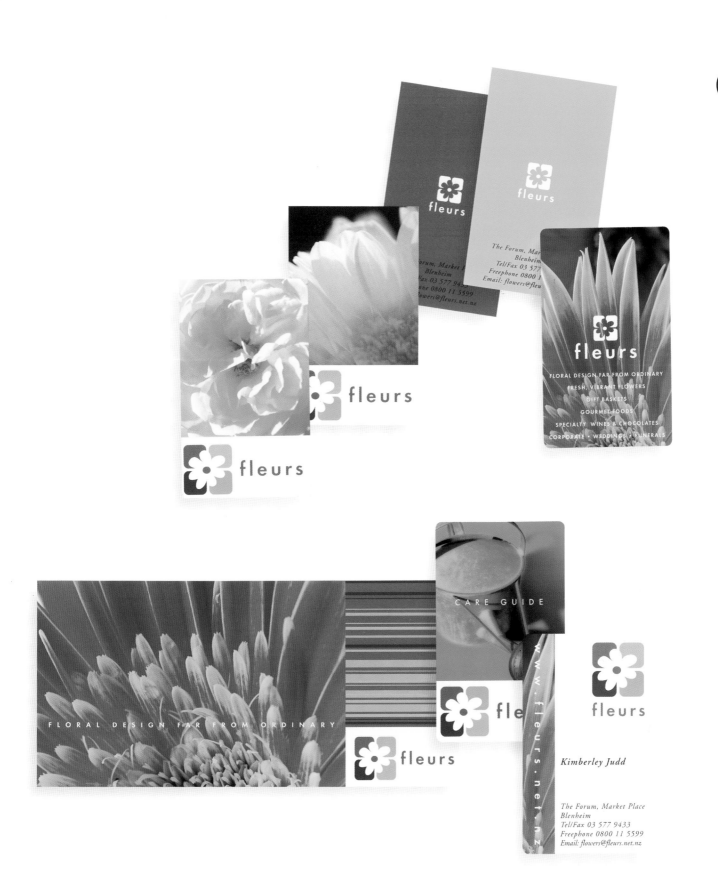

FLORAL DESIGN FAR FROM ORDINARY
FRESH, VIBRANT FLOWERS
GIFT BASKETS
GOURMET FOODS
SPECIALTY WINES & CHOCOLATES
CORPORATE • WEDDINGS • FUNERALS

The Forum, Market Place
Blenheim
Tel/Fax 03 577 9433
Freephone 0800 11 5599
Email: flowers@fleurs.net.nz

CARE GUIDE

Kimberley Judd

The Forum, Market Place
Blenheim
Tel/Fax 03 577 9433
Freephone 0800 11 5599
Email: flowers@fleurs.net.nz

FLORAL DESIGN FAR FROM ORDINARY

EDUCATION, HEALTH, AND NONPROFIT

1

2

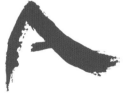

THE UNITED STATES
CONFERENCE OF MAYORS

CANCER AWARENESS PROGRAM

1 **LEWIS COMMUNICATIONS** | ART DIRECTOR **ROBERT FROEDGE** | CLIENT **FLORIDA'S GREAT NORTHWEST**
2 **HAMBLY & WOOLLEY** | CLIENT **U.S. CONFERENCE OF MAYORS**

ICA

ELIZABETH LESSNER
DEVELOPMENT ASSISTANT
617.927.6606
LESSNER@ICABOSTON.ORG

THE INSTITUTE OF
CONTEMPORARY ART
955 BOYLSTON BOSTON 02115 USA

955 BOYLSTON BOSTON MASSACHUSETTS 02115 USA WWW.ICABOSTON.ORG FAX 617.266.4021 PHONE 617.266.5152

THE INSTITUTE OF
CONTEMPORARY ART
955 BOYLSTON BOSTON 02115 USA

955 BOYLSTON BOSTON MASSACHUSETTS 02115 USA WWW.ICABOSTON.ORG FAX 617.266.4021 PHONE 617.266.5152

PLUS DESIGN INC. | ART DIRECTOR **ANITA MEYER** | DESIGNERS **ANITA MEYER, VIVIAN LAW** | CLIENT **THE INSTITUTE OF CONTEMPORARY ART**

1

2

3

4

1 BECKER DESIGN | DESIGNER NEIL BECKER | CLIENT CAVION

2 LOVE COMMUNICATIONS | ART DIRECTOR PRESTON WOOD | DESIGNERS CRAIG LEE, PRESTON WOOD | CLIENT CRAIG LEE

3 PEPE GIMENO—PROYECTO GRAFICO/ESTUDIO PACO BASCUNAN | ART DIRECTORS PEPE GIMENO, PACO BASCUNAN | DESIGNERS PEPE GIMENO, PACO BASCUNAN, DIDAC BALLESTER | CLIENT ENTITAT DE TRANSPORTS METROPOLITAN DE VALENCIA

4 WAVE 3 | DESIGNER RHONDA HARSHFIELD | CLIENT LOUISVILLE REALTORS.COM

1

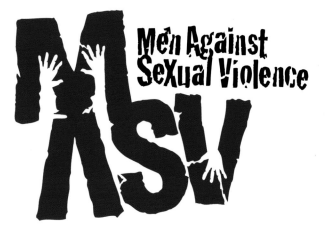

2

1 KNEZIC/PAVONE | ART DIRECTOR ROBINSON C. SMITH | CLIENT PENNSYLVANIA COALITION AGAINST RAPE
2 LOVE COMMUNICATIONS | ART DIRECTOR PRESTON WOOD | DESIGNER CRAIG LEE | CLIENT CRAIG LEE

1

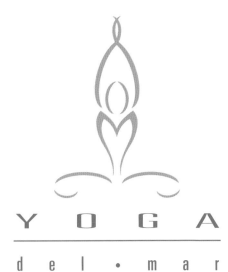

Y O G A

d e l • m a r

2

3

1 MORRIS CREATIVE INC. | ART DIRECTOR STEVEN MORRIS | DESIGNER JEANNE ELEFANTE | CLIENT YOGA DEL MAR

2 RICK JOHNSON & COMPANY | DESIGNER TIM McGRATH | CLIENT N.M. TRAFFIC SAFETY

3 ATELIER TADEUSZ PIECHURA | ART DIRECTOR TADEUSZ PIECHURA | CLIENT UNIWERSYTET MEDYCZNY W TODZI

the cloud foundation

the cloud foundation

cloud place
647 boylston street boston massachusetts 02116
www.cloudfoundation.org
phone 617.262.2949 fax 617.262.2848

the cloud foundation

email info@cloudfoundation.org www.cloudfoundation.org

cloud place 647 boylston street boston massachusetts 02116 phone 617.262.2949 fax 617.262.2848

PLUS DESIGN INC. | ART DIRECTOR **ANITA MEYER** | DESIGNERS **ANITA MEYER, VIVIAN LAW** | CLIENT **THE CLOUD FOUNDATION**

1

2

3

1 DUO DESIGN | DESIGNERS VALTERS LINDBERGS, EMMANUELLE BECKER | CLIENT FRANCE TELECOM FORMATION

2 LEAGAS DELANEY SF | DESIGNER EMILIA FILIPOI | CLIENT STEP UP NETWORK

3 HONEY DESIGN | ART DIRECTOR ROBIN HONEY | DESIGNER JASON RECKER | CLIENT CALLAGHAN CONSULTING

1

2

1 GUNNAR SWANSON DESIGN OFFICE | ART DIRECTOR GUNNAR SWANSON | CLIENT CALIFORNIA STATE POLYTECHNIC UNIVERSITY

2 I. PARIS DESIGN | ART DIRECTOR ISAAC PARIS | CLIENT NATURAL GAS VEHICLES

T D C T J H T B I P C

T D C T J H T B I P C

the redoubtable potentate
MR. THARP
phone 408.354.6726 *fax* 408.354.1450

50 University Ave., Loft 21 | Los Gatos, CA 95030 | WWW.TDCTJHTBIPC.ORG

1

creative**adoptions**

3

mennt.is

2

ABC No RIO

1 FRESHBRAND, INC. | ART DIRECTOR MARCEL VENTER | CLIENT CREATIVE ADOPTIONS
2 GOTT FOLK MCCANN-ERIKSON | ART DIRECTOR EINRA GYLFAYSON | CLIENT MENNT.IS
3 AIR DESIGN | ART DIRECTOR NOAH SCALIN | CLIENT ABC NO RIO

Science Council of British Columbia

Helping

Make

Tomorrow

Happen

in BC

Science Council of British Columbia

Suite 800

4710 Kingsway

Burnaby

British Columbia

Canada V5H 4M2

Telephone

(604) 438-2752

Call Toll Free

1-800-665-SCBC (7222)

Facsimile

(604) 438-6564

1

ART *works!*
CREATIVE SOLUTIONS FOR CHANGE

2

BOOK OF LIFE
Jewish Community Foundation

3

1 **FUSZION COLLABORATIVE** | ART DIRECTOR **JOHN FOSTER** | CLIENT **AMERICANS FOR THE ARTS**
2 **MORRIS CREATIVE INC.** | ART DIRECTOR **STEVEN MORRIS** | DESIGNER **TRACY MEINERS** | CLIENT **COMMUNITY FOUNDATION**
3 **SAYLES GRAPHIC DESIGN** | ART DIRECTOR **JOHN SAYLES** | CLIENT **GIRL SCOUTS OF CHICAGO**

critical **support**

OUR HOSPITAL, OUR FUTURE

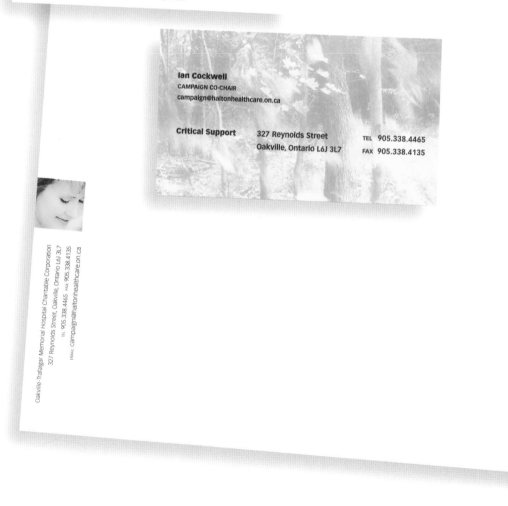

critical **support**

OUR HOSPITAL, OUR FUTURE

Oakville-Trafalgar Memorial Hospital Charitable Corporation

Ian Cockwell
CAMPAIGN CO-CHAIR
campaign@haltonhealthcare.on.ca

Critical Support 327 Reynolds Street TEL 905.338.4465
Oakville, Ontario L6J 3L7 FAX 905.338.4135

Oakville-Trafalgar Memorial Hospital Charitable Corporation
327 Reynolds Street, Oakville, Ontario L6J 3L7
TEL 905.338.4465 FAX 905.338.4135
EMAIL campaign@haltonhealthcare.on.ca

National Cancer Institute of Canada

1

2

1 **HAMBLY & WOOLLEY** | ART DIRECTOR **BARB WOOLLEY** | DESIGNER **DOMINIC AYRE** | CLIENT **NATIONAL CANCER INSTITUTE OF CANADA**
2 **SAYLES GRAPHIC DESIGN** | ART DIRECTOR **JOHN SAYLES** | CLIENT **METRO ARTS ALLIANCE**

1

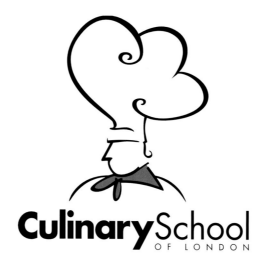

CulinarySchool
OF LONDON

2

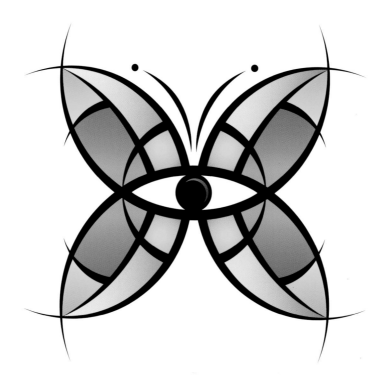

CUBITT
Gallery and Studios
8 Angel Mews
London N1 9HH
T +44 (0)20 7278 8226
F +44 (0)20 7278 2544
E info@cubittartists.org.uk
www.cubittartists.org.uk

Cubitt Artists Limited
Company Limited by Guarantee
Registered in England and Wales No. 2748849
Registered Charity No. 1049653
Registered Office 315 — 317 Ballards Lane, London N12 8LY

RECREATION AND ENTERTAINMENT

1

EMI
FILM & TV MUSIC

2

CALIFORNIA
Center for the Arts
ESCONDIDO

3

rayo

1 EMI FILM AND TV | ART DIRECTOR MICHELLE AZZOPAROI | DESIGNER ROBERT FISHER FOR FLYING FISH | CLIENT EMI FILM AND TV
2 MORRIS CREATIVE GROUP | ART DIRECTOR STEVEN MORRIS | CLIENT CALIFORNIA CENTER FOR THE ARTS
3 MUCCA DESIGN | ART DIRECTOR MATTEO BOLOGNA | DESIGNER ANDREA BROWN | CLIENT HARPER COLLINS

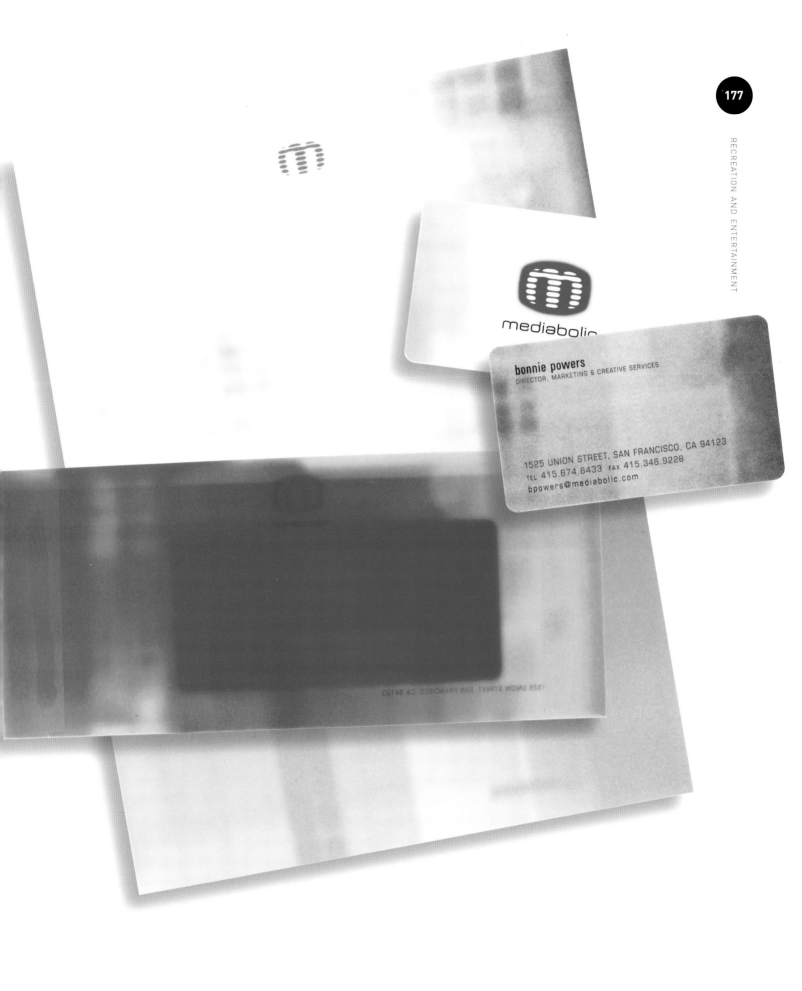

mediabolic

bonnie powers
DIRECTOR, MARKETING & CREATIVE SERVICES

1525 UNION STREET, SAN FRANCISCO, CA 94123
TEL 415.674.6433 FAX 415.346.9228
bpowers@mediabolic.com

TOM & JOHN: ADC | ART DIRECTORS **TOM SIEU, JOHN GIVENS** | CLIENT **MEDIABOLIC**

1

A WorldSpace Channel

2

1 **FUSZION COLLABORATIVE** | ART DIRECTOR **RICHARD LEE HEFFNER** | DESIGNER **CHRISTIAN BALDO** | CLIENT **WORLDSPACE**
2 **UP DESIGN BUREAU** | ART DIRECTOR **TRAVIS BROWN** | CLIENT **RICHMOND RACEWAY**

1

LSO

2

3

4

raissa

5

DAVE STEWART

1 **LSD** | ART DIRECTOR **LAURENCE STEVENS** | DESIGNER **LAURENCE STEVEN** | CLIENT LAURENCE STEVENS DESIGN

2 **LSD** | ART DIRECTOR **LAURENCE STEVENS** | DESIGNER **LAURENCE STEVEN** | CLIENT SONY MUSIC

3 **LSD** | ART DIRECTOR **LAURENCE STEVENS** | DESIGNER **LAURENCE STEVEN** | CLIENT C2 MUSIC MANAGEMENT

4 **LSD** | ART DIRECTOR **LAURENCE STEVENS** | DESIGNER **LAURENCE STEVEN** | CLIENT POLYDOR RECORDS UK

5 **LSD** | ART DIRECTOR **LAURENCE STEVENS** | DESIGNER **LAURENCE STEVEN** | CLIENT DAVE STEWART

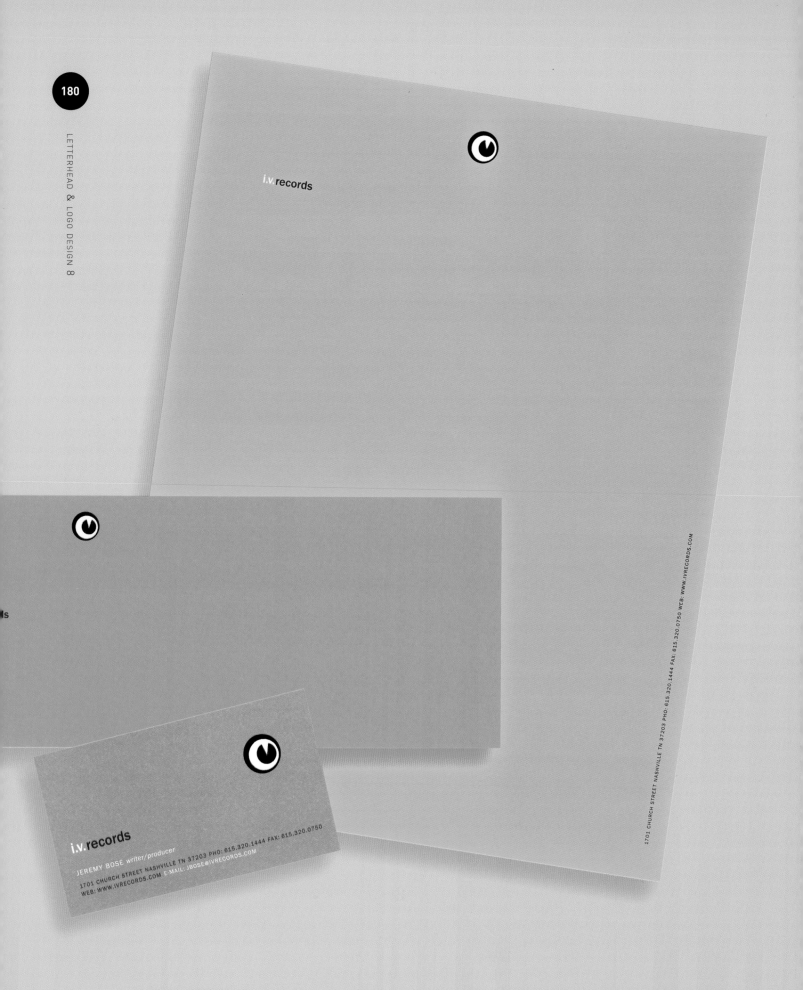

i.v.records

1701 CHURCH STREET NASHVILLE TN 37203 PHO: 615.320.1444 FAX: 615.320.0750 WEB: WWW.IVRECORDS.COM

i.v.records

JEREMY BOSE writer/producer
1701 CHURCH STREET NASHVILLE TN 37203 PHO: 615.320.1444 FAX: 615.320.0750
WEB: WWW.IVRECORDS.COM E-MAIL: JBOSE@IVRECORDS.COM

LEWIS COMMUNICATIONS | ART DIRECTOR ROBERT GROEDGE | CLIENT WHISTLER'S ENTERTAINMENT GROUP

E A S T T O W E R

S O U T H T O W E R

N O R T H T O W E R

GOTTSCHALK + ASH INTERNATIONAL | ART DIRECTOR **STUART ASH** | DESIGNER **SONJA CHOW** | CLIENT **BELL MOBILITY OFFICES**

1

2

1 **CHASE DESIGN GROUP** | ART DIRECTOR **MARGO CHASE** | CLIENT **THE WB TV NETWORK**
2 **CHASE DESIGN GROUP** | ART DIRECTOR **MARGO CHASE** | CLIENT **THE WB TV NETWORK**

1

2

3

1 **CHASE DESIGN GROUP** | ART DIRECTOR **MARGO CHASE** | CLIENT **CHER**
2 **TORNADO DESIGN** | ART DIRECTORS **AL QUATTROCCTTI, JEFF SMITH** | CLIENT **MOCEAN**
3 **TORNADO DESIGN** | ART DIRECTORS **AL QUATTROCCTTI, JEFF SMITH** | CLIENT **HBO**

LITTLE EGG CHARTERS
Light Line and Fly Fishing Guide Service

LITTLE EGG CHARTERS
Light Line and Fly Fishing Guide Service

Capt. Christian Handel • Little Egg Harbor, NJ • 609-812-3563

2

BUENOS AIRES PASTRIES

2

3

1 **ROKFIL DESIGN** | ART DIRECTOR **MARIANA B. PABON** | CLIENT **BUENOS AIRES PASTRIES**
2 **I. PARIS DESIGN** | ART DIRECTOR **ISAAC PARIS** | CLIENT **AMERICAN DANCE THEATER**
3 **SAYLES GRAPHIC DESIGN** | ART DIRECTOR **JOHN SAYLES** | CLIENT **JOHNNY NIGHT TRAIN**

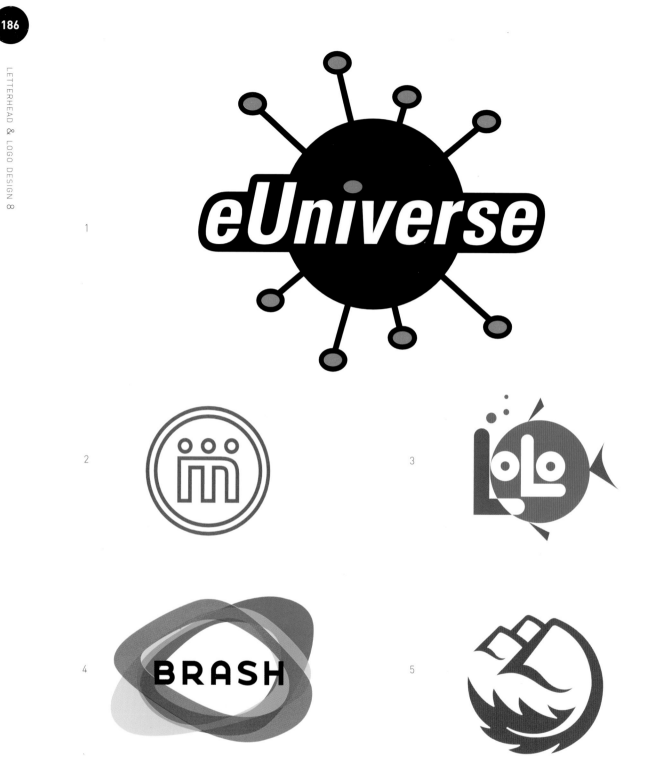

1

2

3

4

5

1 I. PARIS DESIGN | ART DIRECTOR ISAAC PARIS | CLIENT RECORD TIME LABEL

2 PACEY + PACEY | ART DIRECTOR ROBERT PACEY | DESIGNER MICHAEL PACEY | CLIENT VANCOUVER DART ASSOC.

3 SAGMEISTER INC. | ART DIRECTOR STEFAN SAGMEISTER | DESIGNER MATHIAS ERNSTBERGER | CLIENT LOU REED

KOLÉGRAM DESIGN | ART DIRECTOR MIKE TEIXEIRA | CLIENT THÉÂTRE DU TRILLIUM

1

dup

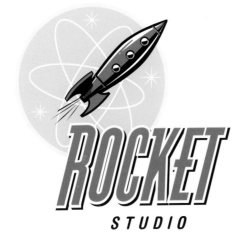

2

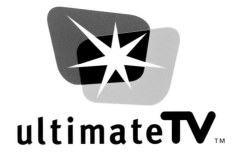

3

1 **LSD** | ART DIRECTOR **LAURENCE STEVENS** | DESIGNER **LAURENCE STEVENS** | CLIENT **ARTIST NETWORK RECORDS**
2 **TORNADO DESIGN** | ART DIRECTORS **AL QUATTROCCTTI, JEFF SMITH** | CLIENT **ROCKET STUDIO**
3 **BE.DESIGN** | ART DIRECTOR **WILL BURKE** | DESIGNERS **ERIC READ, YUSUKE ASAKA** | CLIENT **MICROSOFT**

MISCELLANEOUS

THE Parlor

BECKER DESIGN | ART DIRECTOR NEIL BECKER | DESIGNER SARAH FRITZ | CLIENT THE PARLOR

THE
Parlor

ANN WEBER
PROPRIETOR

W161 N11629 CHURCH ST. GERMANTOWN, WI 53022
P 262 253.6800 F 262 253.0068 theparlorsalon@hotmail.com

THE
Parlor

W161 N11629 CHURCH ST. GERMANTOWN, WI 53022 P 262 253.680...

THE
Parlor

W161 N11629 CHURCH ST. GERMANTOWN, WI 53022

1

2

WRIGHT
AT HOME
LLC

1 DESIGN GUYS | ART DIRECTOR STEVEN SIKORA | DESIGNER JOHN MOES | CLIENT DESIGN GUYS
2 DESIGN GUYS | ART DIRECTOR STEVEN SIKORA | DESIGNER JOHN MOES | CLIENT DESIGN GUYS

Bulldog Drummond

A DAMN FINE AD AGENCY

TELEPHONE
619 528 8404

SINCE
19 97

2741 FOURTH AVENUE
SAN DIEGO, CALIFORNIA 92103
CHARTWELL MANOR

FACSIMILE
619 528 8403

RAMBLINGS OF A CASUAL NATURE

Bulldog Drummond

A DAMN FINE AD AGENCY

SINCE
19 97

CHARTWELL MANOR
SAN DIEGO, CALIFORNIA 92103
2741 FOURTH AVENUE

A DAMN FINE AD AGENCY

SINCE
19 97

ONGOING RAMBLINGS

BULLDOG DRUMMOND | ART DIRECTOR **NEIL BELLEFEVILLE** | DESIGNER **HEIDI ARRIZABALAGA** | CLIENT **BULLDOG DRUMMOND**

ANNA LEE

001 415 794 1220

ANNAYINGLEE@AOL.COM

APPAREL IMPORTS

1

Creative fire

2

**DOORS OPEN
TORONTO**

1 **IN-HOUSE (CREATIVE FIRE)** | ART DIRECTOR **HEATHER McKENDRY** | DESIGNER **HEATHER McKENDRY** | CLIENT **CREATIVE FIRE**
2 **REACTOR ART + DESIGN** | DESIGNERS **SHARI SPIER, JAMES TURNER** | CLIENT **HERITAGE TORONTO**

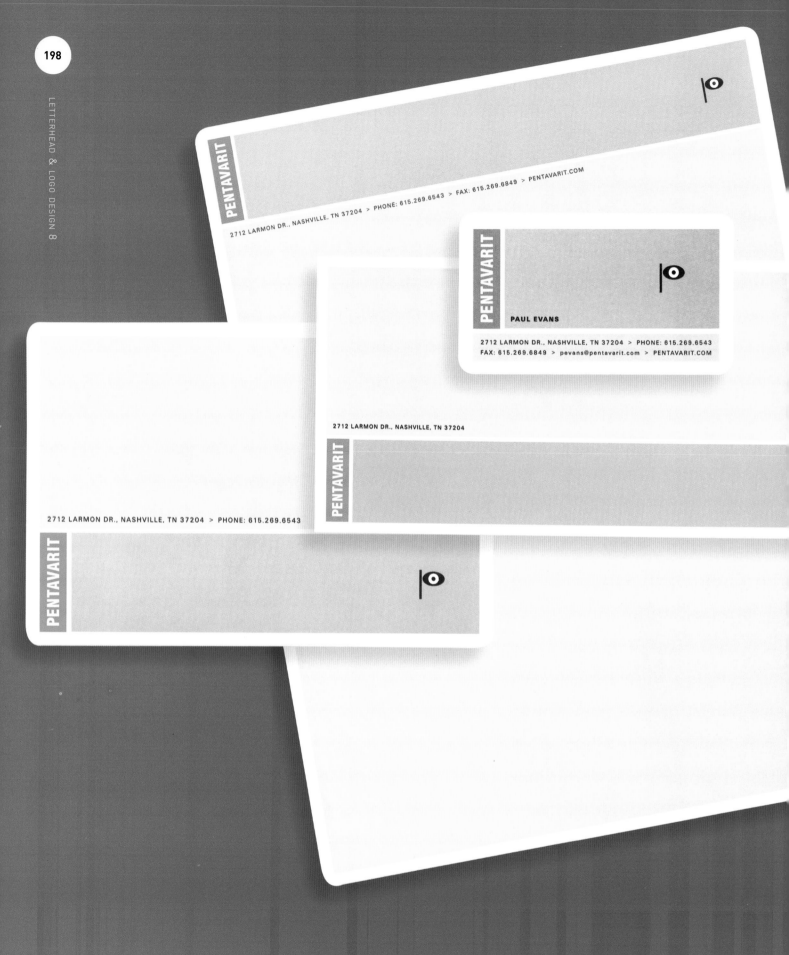

PENTAVARIT

2712 LARMON DR., NASHVILLE, TN 37204 > PHONE: 615.269.6543 > FAX: 615.269.6849 > PENTAVARIT.COM

PENTAVARIT

PAUL EVANS

2712 LARMON DR., NASHVILLE, TN 37204 > PHONE: 615.269.6543
FAX: 615.269.6849 > pevans@pentavarit.com > PENTAVARIT.COM

2712 LARMON DR., NASHVILLE, TN 37204

PENTAVARIT

2712 LARMON DR., NASHVILLE, TN 37204 > PHONE: 615.269.6543

PENTAVARIT

cherry pie

2 YES
YOUR ELECTRICAL SUPPLY SOURCE

3 PAWS
Play, adventure and walking services for your dog.

1 DIGITAL SOUP | ART DIRECTOR PASH | CLIENT CHERRY PIE
2 WAVE 3 | DESIGNER RHONDA HARSHFIELD
3 BAKKEN CREATIVE CO. | ART DIRECTOR MICHELLE BAKKEN | CLIENT PAWS

1

2

1 **DESIGN GUYS** | ART DIRECTOR **STEVEN SIKORA** | DESIGNER **ANNE PETERSON** | CLIENT **ANDRA PATZHOLDT**

2 **MORRIS CREATIVE INC.** | ART DIRECTOR **STEVEN MORRIS** | DESIGNER **DEANNE WILLIAMSON** | CLIENT **WATTERS & WATTERS**

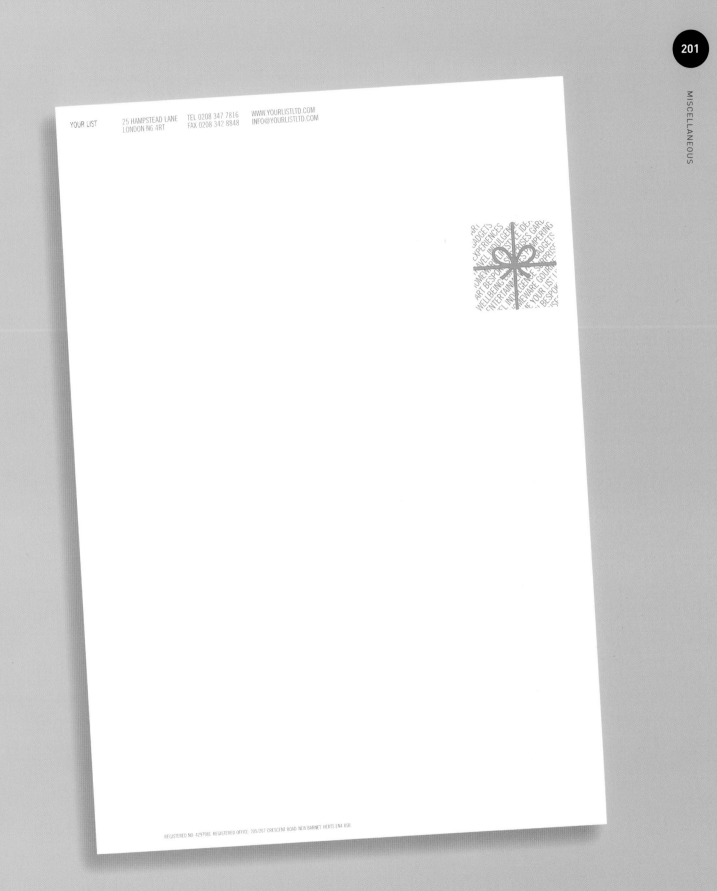

YOUR LIST 25 HAMPSTEAD LANE TEL 0208 347 7816 WWW.YOURLISTLTD.COM
 LONDON N6 4RT FAX 0208 342 8848 INFO@YOURLISTLTD.COM

REGISTERED NO: 4297981 REGISTERED OFFICE: 205/207 CRESCENT ROAD NEW BARNET HERTS EN4 8SB

NB STUDIO | ART DIRECTORS **NICK FINNEY, ALAN DYE, BEN STOTT** | DESIGNER **NICK VINCENT** | CLIENT **YOUR LIST**

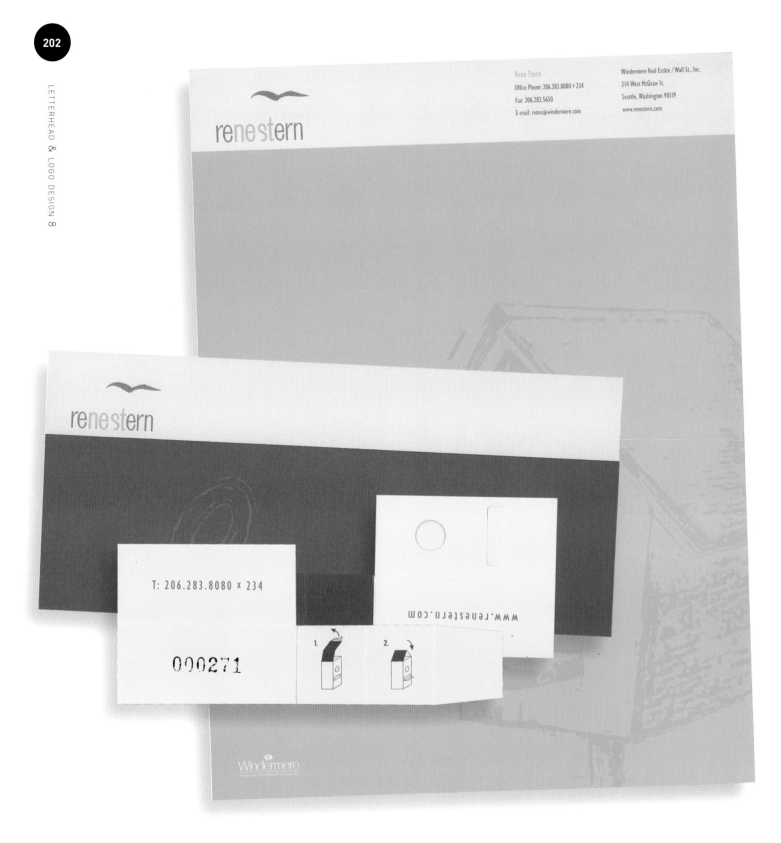

1 abc^2

2 lighthouse

3 intellivoice

1 **HAMBLY & WOOLLEY** | ART DIRECTOR **BARB WOOLLEY** | DESIGNER **DOMINIC AYRE** | CLIENT **ABC2**
2 **WILSON HARVEY** | ART DIRECTOR **PAUL BURGESS** | DESIGNER **RICHARD BAKER** | CLIENT **LIGHTHOUSE**
3 **WILSON HARVEY** | ART DIRECTOR **PAUL BURGESS** | DESIGNER **DANIEL ELLIOTT** | CLIENT **INTELLIVOICE**

NORAC

IMPORT-EXPORT

4405, rue Lafrance
Montréal (Québec) Canada
H2A 2G1
Tél. : (514) 951-9412
Téléc. : (514) 529-8051
Courriel : caronmichel@yahoo.ca

4405 Lafrance Street
Montreal, Quebec, Canada
H2A 2G1
Tel. : (514) 951-9412
Fax : (514) 529-8051
E-mail: caronmichel@yahoo.ca

NORAC

T R A D E R S

Michel Caron
President

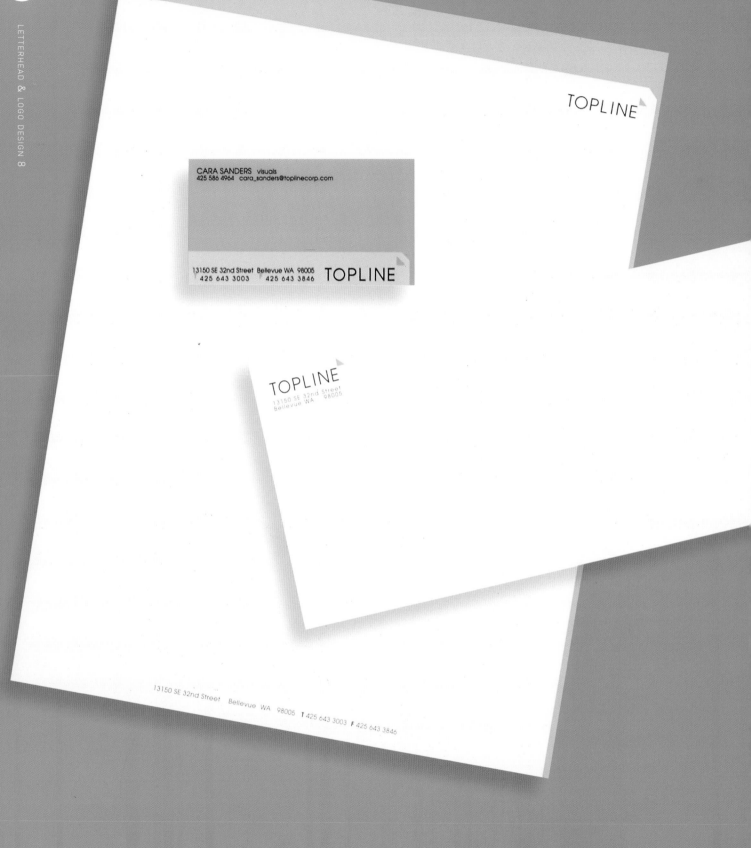

CARA SANDERS visuals
425 586 4964 cara_sanders@toplinecorp.com

13150 SE 32nd Street Bellevue WA 98005
 425 643 3003 425 643 3846

TOPLINE

TOPLINE

TOPLINE
13150 SE 32nd Street
Bellevue WA 98005

13150 SE 32nd Street Bellevue WA 98005 **T** 425 643 3003 **F** 425 643 3846

THE TOPLINE CORPORATION | ART DIRECTOR **HAREL WALDMAN** | DESIGNER **CARA SANDERS** | CLIENT **THE TOPLINE CORPORATION**

1

2

3

1 WILSON HARVEY | ART DIRECTOR PAUL BURGESS | CLIENT ROUTE ONE

2 BECKER DESIGN | DESIGNER NEIL BECKER | CLIENT REDI HELP

3 WILSON HARVEY | ART DIRECTOR PAUL BURGESS | DESIGNER DANIEL ELLIOTT | CLIENT DRAKES GROUP

1

2 NM@F

new mexico's advertising voice

1 WILSON HARVEY | ART DIRECTOR PAUL BURGESS | CLIENT METROCUBE
2 RICK JOHNSON & COMPANY | DESIGNER TIM McGRATH | CLIENT NEW MEXICO AD FED

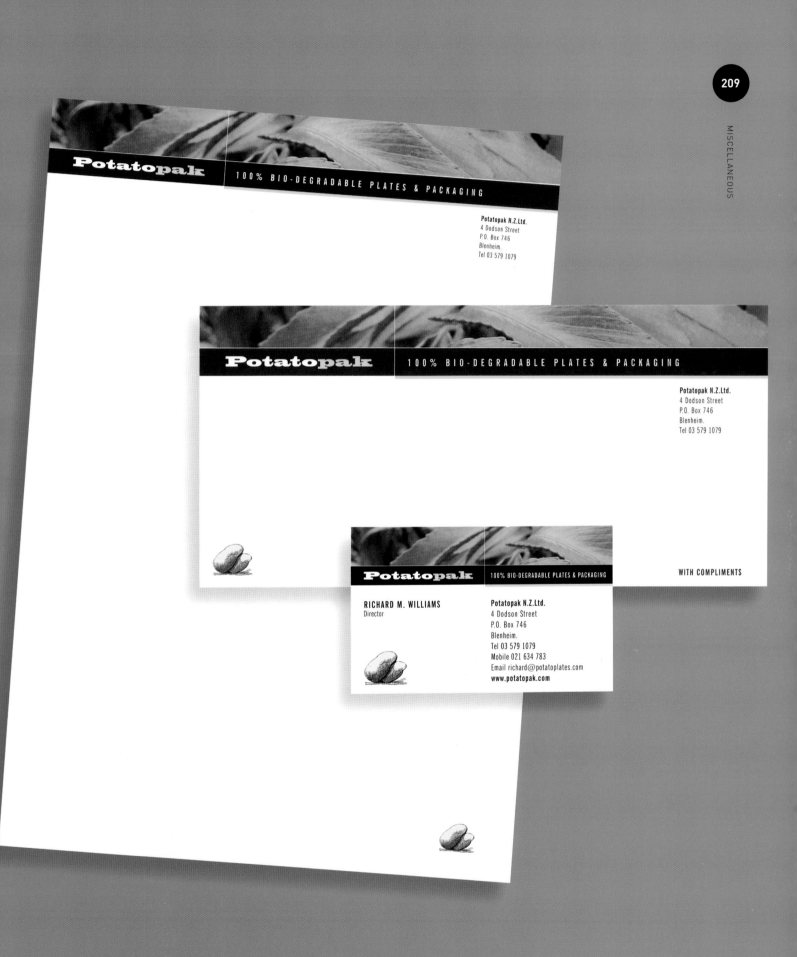

Potatopak

100% BIO-DEGRADABLE PLATES & PACKAGING

Potatopak N.Z.Ltd.
4 Dodson Street
P.O. Box 746
Blenheim.
Tel 03 579 1079

Potatopak

100% BIO-DEGRADABLE PLATES & PACKAGING

Potatopak N.Z.Ltd.
4 Dodson Street
P.O. Box 746
Blenheim.
Tel 03 579 1079

WITH COMPLIMENTS

Potatopak

100% BIO-DEGRADABLE PLATES & PACKAGING

RICHARD M. WILLIAMS
Director

Potatopak N.Z.Ltd.
4 Dodson Street
P.O. Box 746
Blenheim.
Tel 03 579 1079
Mobile 021 634 783
Email richard@potatoplates.com
www.potatopak.com

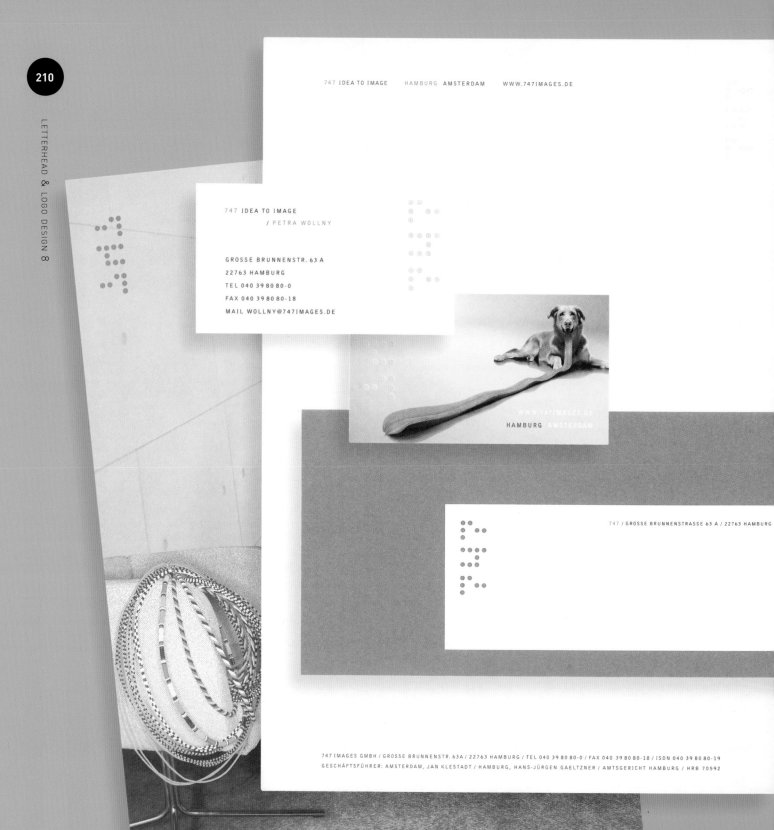

1

2

KINGSLEY
KARDS

a1 **IRIDIUM, A DESIGN AGENCY** | ART DIRECTOR **MARIO L'ECUYER** | CLIENT **CANADIAN RESEARCH CHAIRS**

2 **MORRIS CREATIVE INC.** | ART DIRECTOR **STEVEN MORRIS** | CLIENT **KINGSLEY KARDS**

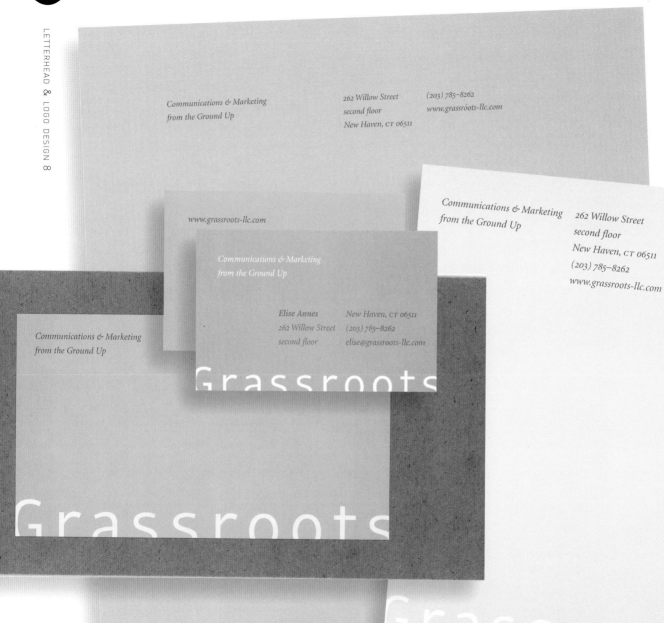

1

jade

2

ajm

1 **DANIEL ELLIOTT** | ART DIRECTOR **DANIEL ELLIOTT** | CLIENT **JADE**
2 **DANIEL ELLIOTT** | ART DIRECTOR **DANIEL ELLIOTT** | CLIENT **AJM**

1

1 □:THELAUNCHPAD

1 **MONDERER DESIGN** | ART DIRECTOR **STUART MONDENER** | DESIGNER **JEFFREY GOBIN** | CLIENT **SOCKEYE NETWORKS**

 Archer Street

Frank Cottrell Boyce

 Archer Street

Studio 5, 10-11 Archer Street
London W1V 7HG
tel. +44 (0)20 7439 0540
fax. +44 (0)20 7437 1182
email. frank@archerstreet.com

with compliments

Archer Street

Studio 5, 10-11 Archer Street
London W1V 7HG
tel. +44 (0)20 7439 0540
fax. +44 (0)20 7437 1182
email. films@archerstreet.com

Archer Street Limited
Studio 5, 10-11 Archer Street
London W1V 7HG
tel. +44 (0)20 7439 0540
fax. +44 (0)20 7437 1182
email. films@archerstreet.com

Directors: Andy Paterson
Frank Cottrell Boyce Anand Tucker

Company Registered No. 3537276

Registered Address:
10 Orange Street, London WC2H 7DQ

1

2

Y'know
71 beak street london W1F 9SP
tel +44 (0)20 7439 4780 fax +44 (0)20 7439 4775
enquiries@yknow.com

... GOLDEN BOOTS

ebdon	s.davis
	taylor
doherty	

Catwoman	The Riddler	The Joker	Penguin	Poison Ivy	Harly Quinn		
sulphuric acid	battery acid	lemon juice	orange juice	coffee	tea	Doctor Destiny	Harvey Dent
Olive Oil	Spaghetti	water	milk	blood	sea water	calculator	King Tut
Baking soda	milk of magnesia	salt	lime	Domestic Bleach	Caustic Soda		

y'know

Jolyon Gadd

71 beak street london W1F 9SP
tel +44 (0)20 7439 4780 fax +44 (0)20 7439 4775
Mobile 07775 863 792 jolyon@yknow.com

WESTERNS

River Phoenix	Dylan Thomas	Lord Byron	Neal Cassady	Ken Kesey	Jim Morrison
			Sid Vicious	Nick Drake	Keith Moon
			Oliver Reed	DJ Screw	Charles Bukowski

... BIG NAMES

y'know

y'know
71 beak street london W1F 9SP
tel +44 (0)20 7439 4780
fax +44 (0)20 7439 4775
enquiries@yknow.com

Kathy Bates	Rosie O'Donnell	Rik Waller	John Belushi	Ricki Lake	John Candy	John Goodman
Winston Churchill	Oliver Hardy	Chubby Checker	Orson Welles	Roosevelt	Maradona	Sydney Greenstreet

1

2

HOME PACKAGE DELIVERY BOX

3

4

1 **CITY OF KITCHENER** | ART DIRECTOR JOLENE MacDONALD | CLIENT CIRCA DEVELOPMENT

2 **HG DESIGN** | ART DIRECTOR STEVE COOPER | CLIENT BOBBYBOX

3 **SAYLES GRAPHIC DESIGN** | ART DIRECTOR JOHN SAYLES | CLIENT MOORE FAMILY

4 **SAYLES GRAPHIC DESIGN** | ART DIRECTOR JOHN SAYLES | CLIENT SAYLES GRAPHIC DESIGN

1

westone
PLASTIC AND COSMETIC SURGERY

2

riskcapitalpartners

3

ellisknox
PRODUCT INNOVATION

charlotte sanderson (dip.ISD) garden & landscape design

23 coldstream gardens london SW18 1LJ **t/f** 020 8877 9167 **m** 07748 651 653
e charlotte@sandersongardendesign.com **i** www.sandersongardendesign.com

charlotte sanderson (dip.ISD)
garden & landscape design

23 coldstream gardens london SW18 1LJ
t/f 020 8877 9167 **m** 07748 651 653
e charlotte@sandersongardendesign.com
i www.sandersongardendesign.com

HAT-TRICK DESIGN | ART DIRECTORS **JIM SUTHERLAND, GARETH HOWAT** | DESIGNER **JIM SUTHERLAND, GARETH HOWAT, JAMIE ELLUE** | CLIENT **CHARLOTTE SANDERSON**

DIRECTORY

178 AARDIGE ONTWEPERS
Amsterdam, Netherlands
info@178aardigeontwepers.nl

A2-GRAPHICS/SW/HK
London, United Kingdom
info@a2-graphics.co.uk

AFTERHOURS GROUP
Jakarta, Indonesia
brahm@afterhoursgroup.com

AIR DESIGN
Richmond, VA, USA
noah@airdesign.com

ANGRY PORCUPINE DESIGN
Cupertino, CA, USA
cheryl@angryporcupine.com

A PLUS B
New York, NY, USA
ab_alx@yahoo.com

ATELIER TADEUSZ PIECHURA
Lodz, Poland
jjw@uni-film.pl

BAKKEN CREATIVE CO.
Berkeley, CA, USA
mbakken@bakkencreativeco.com

BALANCE DESIGN
Greenwich, CT, USA
carey@balancedesign.net

BE.DESIGN
San Rafael, CA, USA
shinichi_eguchi@beplanet.com

BEAULIEU CONCEPTS GRAPHIQUES INC.
Candiac, Quebec, Canada
bcg@videotron.ca

BECKER DESIGN
Milwaukee, WI, USA
neil@beckerdesign.net

BENCIUM
Budapest, Hungary
csbence@bencium.hu

BULLDOG DRUMMOND
San Diego, CA, USA
catharine@bulldogdrummond.com

BURD & PATTERSON
W. Des Moines, IA, USA

CAHAN AND ASSOCIATES
San Francisco, CA, USA
info@cahanassociates.com

CAHOOTS
Boston, MA, USA
carol@cahootsdesign.com

CATO PURNELL PARTNERS
Richmond, Victoria, Australia
melbourne@cato.com.au

CDT DESIGN
London, United Kingdom
stuart@cdt-design.co.uk

CHASE DESIGN GROUP
Los Angeles, CA, USA
husam@chasedesigngroup.com

CHEN DESIGN ASSOCIATES
San Francisco, CA, USA
info@chendesign.com

CFX CREATIVE
Bellingham, WA, USA
info@cfxcreative.com

CITY OF KITCHENER
Kitchener ON, Canada
terry.marr@city.kitchener.on.ca

CPD
Melbourne, Victotia, Australia
d.ohehir@cpdtotal.com.au

CREATIVE FIRE
Bellingham, WA, USA
hmckendry@earthlink.net

D. DESIGN
London, United Kingdom
dereksamuel@virgin.net

DANIEL ELLIOTT
London, United Kingdom
delliott@hotmail.com

DESIGN GUYS
Minneapolis, MN, USA
info@designguys.com

DEW GIBBONS
London, United Kingdom
caty@dewgibbons.com

DIGITAL DESIGN WORKS
Gladwyne, PA, USA
mbugler@ddwinc.com

DIGITAL SOUP
Culver City, CA, USA
pash@digitalsoup.com

DIECKS GROUP
New York, NY, USA
claire@diecks.com

DIL BRANDS
São Paulo, Brazil
dilpackdesign@dil.com.br

DUCKS DESIGN, HAMBURG
Hamburg, Germany
contact@duckdesign.de

DUO DESIGN
Charenton-le-pont, France
duodesign@wanadoo.fr

EMERY VINCENT DESIGN
Surrey Hills, Sydney, Australia
sharon.nixon@emeryvincentdesign.com

EMI FILM AND TV
Los Angeles, CA, USA
michelle.azzopardi@emicap.com

EMMA WILSON DESIGN CO.
Seattle, WA, USA
emma@emmadesignco.com

ENERGY ENERGY DESIGN
Los Gatos, CA, USA
lesleyg@nrgdesign.com

ENTERPRISE IG
Tokyo, Japan
hidetaka.matsunaga@enterpriseig.com

FIREBOX MEDIA
San Francisco, CA, USA
audrey@fireboxmedia.com

FORMAT DESIGN
Hamburg, Germany
ettling@format.hh.com

FRESHBRAND, INC.
Denver, CO, USA
marcel@freshbrand.com

FUSZION COLLABORATIVE
Alexandria, VA, USA
john@fusion.com

GARY BASEMAN
Los Angeles, CA, USA
basemanart@earthlink.net

GASKET
Paddington, Brisbane, Australia
plazma@gil.com.av

GILLESPIE DESIGN, INC.
New York, NY, USA
maureen@gillespiedesign.com

GINGER BEE CREATIVE
Helena, MT, USA
gingerbee@qwest.net

GOTT FOLK McCANN-ERICKSON
Reykjavic, Iceland
einar@gottfolk.is

GOTTSCHALK + ASH INTERNATIONAL
Toronto, ON, Canada
info@gplusa.com

GRAPHISCHE FORMGEBUNG
Bochum, Germany
Herbert.rohsiepe@gelsen.net

GUNNAR SWANSON DESIGN OFFICE
Ventura, CA, USA
gunnar@gunnarswanson.com

GWEN FRANCIS DESIGN GROUP
Cupertino, CA, USA

HAMBLY & WOOLLEY
Toronto, ON, Canada
bobh@hamblywoolley.com

HAT-TRICK DESIGN
London, United Kingdom
jamie@hat-trickdesign.co.uk

HEAD QUARTER
Mainz, Germany
head@headquater.com

HG DESIGN
Wichita, KS, USA
scooper@hgdesign.com

HINGE
Chantilly, VA, USA
doug@studiohinge.com

HONEY DESIGN
London, ON, Canada
jason@honey.on.ca

I PARIS DESIGN
Brooklyn, NY, USA
iparisdgn@gis.net

ICEHOUSE DESIGN
New Haven, CT, USA
bjoran.akselsen@snet.net

IDEOGRAMA
Cuernavac, Morocco, Mexico
pep@ideograma.com

IMAGINE THAT DESIGN STUDIO
San Francisco, CA, USA
doit@imaginethatsf.com

INOX DESIGN
Milan, Italy
mauro@inoxdesign.it

INSIGHT DESIGN COMMUNICATIONS
Wichita, KS, USA
tracy@idcweb.net

IRIDIUM, A DESIGN COMPANY
Ottawa, ON, Canada
mario@iridium192.com

JANE CAMERON DESIGN
Adelaide, SA, Australia
jcd@adelaide.on.net

KARIZMA CULTURE
Vancouver, Canada
perryc@telus.net

KNEZIC/PAVONE
Harrisburg, PA, USA
rsmith@kpadv.net

KOLÉGRAM DESIGN
Hull, QC, Canada
mike@kolegram.com

LAURENCE STEVENS DESIGN (LSD)
London, England, UK
info@lsdvision.co.uk

LAVA GRAPHIC DESIGNERS
Netherlands
fieke@lava.nl

LE-PALMIER
Hamburg, Germany
design@lepalmiev.de

LEAGAS DELANEY SF
San Francisco, CA, USA
amelia.filipoi@leagassf.com

LEMLEY DESIGN CO.
Seattle, WA, USA
david@lemleydesign.com

LEWIS COMMUNICATIONS
Nashville, TN, USA
robert@lewiscommunications.com

LISKA + ASSOCIATES
Chicago, IL, USA
agray@liska.com

**LLOYD'S GRAPHIC DESIGN
AND COMMUNICATION**
Belenheim, New Zealand
lloydgraphics@xtra.co.nz

LOVE COMMUNICATIONS
Salt Lake City, UT, USA
pwood@lovecomm.net

MALIK DESIGN
South Amboy, NJ, USA
kilam@optonline.net

MARIUS FAHRNER DESIGN
Hamburg, Germany
marius@formgefuehl.de

METHOD
San Francisco, CA, USA
patrick@method.com

METZLER & ASSOCIATES
Paris, France
maherrmann@metzler.fr

MIASO DESIGN
Chicago, IL, USA
kristin@miasodesign.com

**MICHAEL POWELL DESIGN &
ART DIRECTION**
Memphis, TN, USA
mpowell6@midsouth.rr.com

MIAMI AD SCHOOL
Miami Beach, FLUSA

ML DESIGN
Los Angeles, CA, USA
marielafa@earthlink.net

MONDERER DESIGN
Cambridge, MA, USA
stewart@monderer.com

MONSTER DESIGN
Redmond, WA, USA
denise@monsterinvasion.com

MORRIS CREATIVE, INC.
San Diego, CA, USA
aimme@thinkfeelwork.com

MORTENSEN DESIGN
Mountain View, CA, USA
gmort@mortdes.com

MUCCA DESIGN
New York, NY, USA
christine.celic@muccadesign.com

NASSAR DESIGN
Brookline, MA, USA
n.nassar@verizon.net

NB STUDIO
London, United Kingdom
mail@nbstudio.co.uk

NESNADNY + SCHWARTZ
Cleveland, OH, USA
info@nsideas.com

NICOLE CHIALA DESIGN
Los Angeles, CA, USA
nixc@jps.net

NORTH BANK
Bath, United Kingdom
simon@northbankdesign.co.uk

PACEY + PACEY
North Vancouver, BC, Canada
paceyandpacey@hotmail.com

PAPER HAT DESIGN WORKS
San Francisco, CA, USA
tom.lyons@leagassf.com

PEPE GIMENO
Godelli, Spain
proyectografico@pepegimeno.com

PLATFORM CREATIVE GROUP
Seattle, WA, USA
cristy@platformcreative.com

PLUS DESIGN INC.
Boston, MA, USA
plus@plusdesigninc.com

POMEGRANATE
London, United Kingdom
shaun@pomegranate.co.uk

PUBLICIDAD GÓMEZ CHICA
Medellin, Columbia
sanjape@hotmail.com or
empaques@gomezchica.com.co

PURE DESIGN INC.
Portland, OR, USA
rachelle@puredesigninc.com

REACTOR ART + DESIGN
Toronto, ON, Canada
shari@reactor.ca

RED DESIGN
Brichton, United Kingdom
rachel@red-design.co.uk

RED STUDIOS
W. Hollywood, CA, USA
ruben@redstudios.com

RE: SALZMAN DESIGNS
Baltimore, MD, USA
ida.cheinman@verizon.net

RICK JOHNSON & CO.
Albuquerque, NM, USA
tmcgrath@rjc.com

THE RIORDON DESIGN GROUP
Oakville, ON, Canada
greer@riordondesign.com

RKS DESIGN
Thousand Oaks, CA, USA
ravi@rksdesign.com

ROBERT FROEDGE DESIGN
Franklin, TN, USA
robert@lewiscommunications.com

ROKFIL DESIGN
Mountain View, CA, USA
mbpdesign@hotmail.com

RUBIN CORDARO DESIGN
Minneapolis, MN, USA
j.cordaro@rubincordaro.com

SAGMEISTER, INC.
New York, NY, USA
ssagmeister@aol.com

SAYLES GRAPHIC DESIGN
Des Moines, IA, USA
sheree@saylesdesign.com

SMULLEN DESIGN

SPECIAL MODERN DESIGN
Los Angeles, CA, USA
kk@kbarranco.com

STILRADAR
Stuttgart, Germany
info@stilradar.de

STUDENT WORK
Kansas City, MO, USA
raka@uzigzag.com

TESSER, INC.
San Francisco, CA, USA
debra.naeve@tesser.com

THARP DID IT
Los Gatos, CA, USA

THE TOPLINE CORPORATION
Bellevue, WA, USA
cara_sanders@toplinecorp.com

THINKDESIGN & COMMUNICATIONS, INC.
Falls Church, VA, USA
jim@thinkdesign.net

TOM & JOHN: ADC
San Francisco, CA, USA
tom@tom-john.com

TOP DESIGN STUDIO
Toluca Lake, CA, USA
info@topdesign.com

TONG DESIGN
Tai Pei, Taiwan
tong8888@cm1.ethome.net.tw

TORNADO DESIGN
Los Angeles, CA, USA
alq@tornadodesign.la

UTILITY DESIGN
New York, NY, USA
www.utilitydesign.net

UP DESIGN BUREAU
Wichita, KS, USA
cp@vpdesignbureau.com

VRONTIKIS DESIGN OFFICE
Los Angeles, CA, USA
pv@35k.com

WALLACE CHURCH, INC.
New York, NY, USA
wendy@wallacechurch.com

WAVE 3
Louisville, KY, USA
art@wave3tv.com

WHY NOT ASSOCIATES
London, United Kingdom
info@whynotassociates.com

WILSON HARVEY
London, United Kingdom
paulb@wilsonharvey.co.uk

YES DESIGN
Glendale, CA, USA
yes-bas@pacbell.net

ZIGZAG DESIGN
Kansas City, MO, USA
raka@uzigzag.com

INDEX

SPECIAL THANKS TO:

Peleg Top for his vision, leadership, and inspiration,

Alexis Mercurio for her diligence, dedication, and talent,

Rebekah Beaton for her style and sophistication,

Shachar Lavi for her spirit and spunk,

Karen Shakarov for her passion and drive,

Molly Stretten for keeping us all in check,

Terese Harris for her efforts, precision, and lemon curd tarts,

Kristin Ellison for her confidence and assurance,

David Martinell for his direction and diplomacy,

Ricky Hoyt for his words and wisdom.